BETTER PICTURE GUIDE TO

Landscape
photography

RotoVision

A RotoVision Book

Published and Distributed by RotoVision SA
Rue du Bugnon 7
CH-1299 Crans-Près-Céligny
Switzerland

RotoVision SA, Sales & Production Office
Sheridan House, 112/116A Western Road
Hove, East Sussex BN3 1DD, UK

Tel: +44 (0)1273 72 72 68
Fax: +44 (0)1273 72 72 69

Distributed to the trade in the United States by:
Watson-Guptill Publications
1515 Broadway
New York, NY 10036

10 9 8 7 6 5 4 3

ISBN 2-88046-370-X

Book design by Brenda Dermody

Production and separations in Singapore by ProVision Pte. Ltd.
Tel: +65 334 7720
Fax: +65 334 7721

BETTER PICTURE GUIDE TO

Landscape
photography

MICHAEL BUSSELLE

Contents

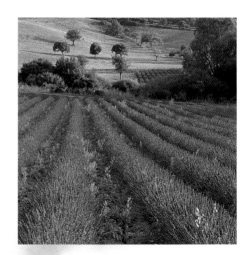

The Subject

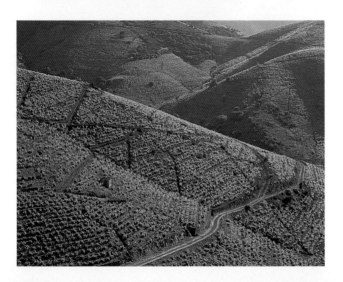

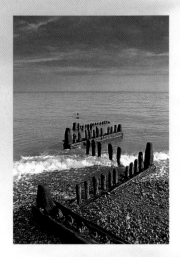

Landscape photography encompasses
an enormous variety of subjects and
styles and this chapter describes the most popular themes and
demonstrates the approach and techniques needed to produce the
most telling results.

Rural Views

The term landscape in the context of photography can mean a great many different things, but perhaps the most common perception is that of the classic rural view. It is most often a stunning view which makes people reach for their cameras but, paradoxically, it can be this particular type of landscape photograph which most frequently disappoints.

Seeing

I'd arrived at this location in the late afternoon of a crisp December day when the sunlight was sharp and clear and I was immediately struck by the effect which the warm light had on the red bracken.

Thinking

I noticed that beyond there were clouds gathered over the distant mountains, casting a shadow over them. I thought that this would make an effective contrast to the well-lit foreground and accentuate the red foliage.

Acting

I climbed on to a rise in the ground, which gave me a slightly higher viewpoint and showed more of the mountains and used a long-focus lens to frame the most colourful and interesting part of the foreground quite tightly. I used a polarising filter to maximise the colour saturation, an 81C warm-up filter to enhance the red bracken and a neutral-graduated filter to make the clouds and shadowed mountains a little darker.

Technical Details
▼ 6 x 4.5cm SLR camera with a 105–210mm zoom lens on Fuji Velvia.

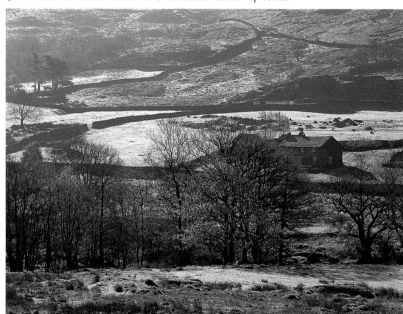

The valley of the River Duddon near Ulpha in Cumbria, UK

This springtime shot, taken in the early morning, appealed to me because the back lighting had created an almost monochromatic effect. I used a long-focus lens to isolate a small area of the scene which has accentuated the textural quality of the newly emerging leaves and bare branches of the trees.

Near Tarn Howes in Cumbria, UK

Rule of Thumb

Don't try to include too much in your image – this is the most common cause of disappointing results. It is often better to take two or three different photographs of the same scene than it is to attempt to record all of the details in one picture.

Technical Details
▼ 6 x 4.5cm SLR camera with a 105–210mm zoom lens, polarising, 81C warm-up and neutral-graduated filters on Fuji Velvia.

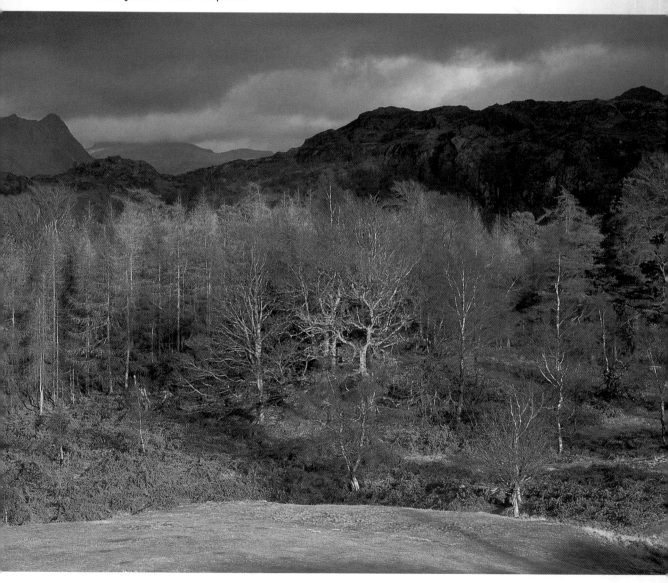

Seeing

It was initially the striking effect of the bare-branched trees silhouetted against a dramatically cloudy sky which attracted Julien Busselle to this scene.

Thinking

He felt that more was needed to make a satisfying composition and found a viewpoint from where the small group of back-lit sheep provided an ideal focus in the foreground.

Acting

Julien framed the shot so the two trees created a frame around the image, along with the shadowed hillock in the immediate foreground, and so they were most effectively placed against the sky. This has helped to concentrate attention on the main focus of interest. He used an 81C warm-up filter to make the colour of the brown grass slightly richer and a neutral-graduated filter to darken the top area of the sky.

Technical Details
▼ 6 x 4.5cm SLR camera with a 55–110mm zoom lens on Fuji Velvia.

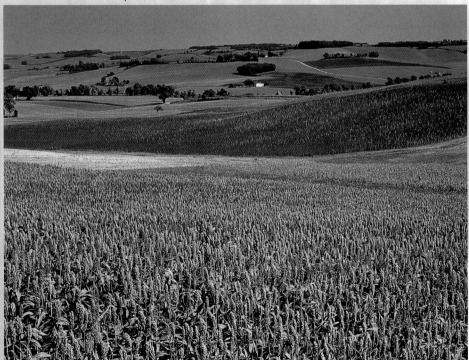

Near the town of Condom in Gascony, France

Shot in the autumn in the middle of the day, when there was a clear blue sky, this scene was rather blandly lit but the strong textural quality of the millet field and the distant dead sunflowers gave the image the necessary degree of bite. I used the highlighted white-walled farmhouse as the focus for the composition and framed the shot so the foreground was emphasised and only a small strip of the featureless sky was included.

Technique

Always look at the possibility of including **foreground details** when shooting distant views, as this can help to create a feeling of depth and distance in the image as well as adding an element of interest to the composition.

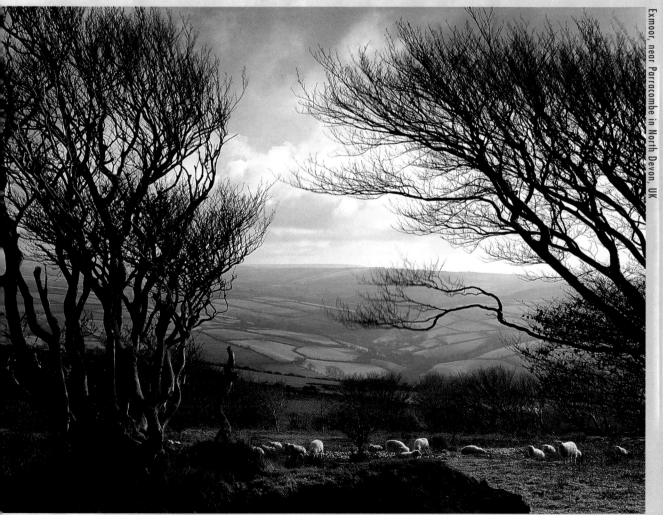

Exmoor, near Parracombe in North Devon, UK

▲ Technical Details
6 x 4.5cm SLR camera with a 55–110mm zoom lens, 81C warm-up and neutral-graduated filters on Fuji Velvia.

The Coast

There is something quite magical about the place where the land meets the sea and as a location for landscape photography it offers an immense variety of possibilities. From broad vistas of the coastline itself to abstract details of rocks and sand, a perceptive photographer will seldom be short of inspiration.

Seeing

It was late in the afternoon of what had been a largely overcast winter's day when I arrived at this spot. The sun had just begun to emerge through a gap in the clouds and the late hour gave it a very pleasing warm quality.

Thinking

The sunlight was also glancing from the fence rail on the left of the path and creating an attractive highlight. I felt the path and fence rail would make an effective foreground and at the same time lead the eye towards the sea, which was intended to be the main feature of the shot.

Acting

I chose a viewpoint which allowed me to include enough of the path and fence to establish them but also included a large area of the sky and sea. I needed to use a very wide-angle lens to frame the image in the way I wanted and used a neutral-graduated filter to prevent the sky from overexposing.

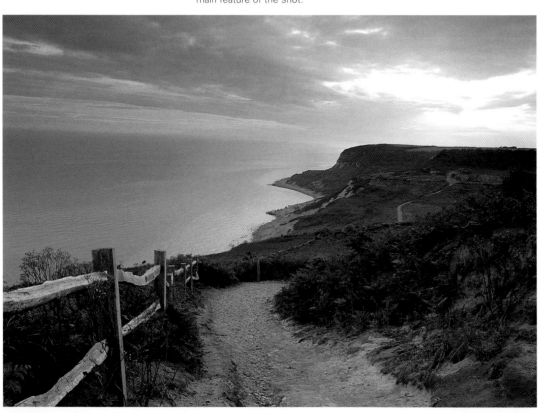

Fairlight Cove near Hastings in East Sussex, UK

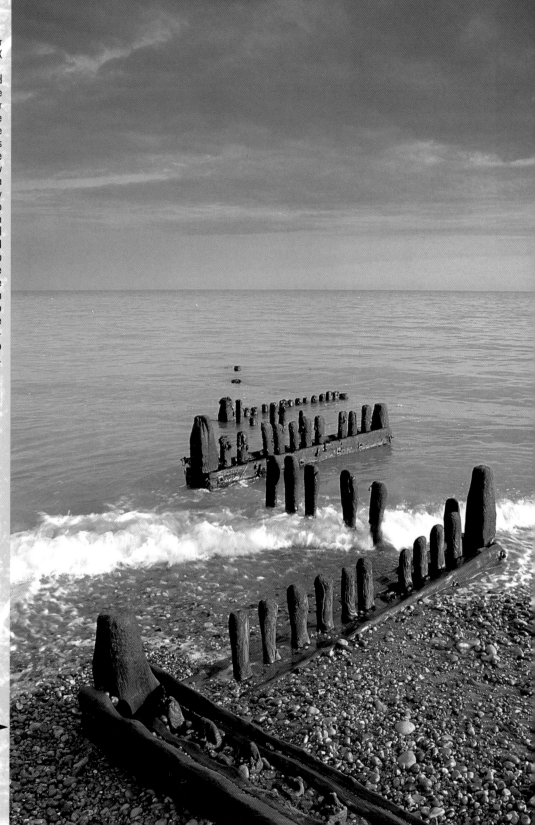

Winchelsea Beach near Rye in East Sussex, UK

The zigzag line created by this eroded groyne was the inspiration for this shot, taken on the same afternoon as the other image on this spread. I used the upright format to allow the inclusion of a generous area of sky and framed the shot so the sky, sea and beach occupied about equal portions of the image. I used an 81C warm-up filter to accentuate the warm quality of the afternoon light, a polarising filter to enrich the colour of the sea and a neutral-graduated filter to darken the sky a little.

Technical Details
35mm SLR camera with a 20–35mm zoom lens, 81C warm-up and neutral-graduated filters on Fuji Velvia.

Technical Details
35mm SLR camera with a 20–35mm zoom lens, 81C warm-up, neutral-graduated and polarising filters on Fuji Velvia.

The Coast

Seeing
It had been cloudy all day and I was returning, without a photograph in the bag, to my hotel when I saw this scene in my rear-view mirror as I drove along the coast road.

Thinking
I needed to find somewhere I could stop quickly on this busy road and also a place where I could have an uninterrupted view of the coastline. A lay-by appeared as if by divine intervention and I quickly set up the camera and framed the shot roughly.

Acting
The clouds were moving swiftly and the breaks between them caused beams of sunlight to flicker through with varying degrees of brightness. I decided to use a neutral-graduated filter as, most of the time, I felt that the brightest part of the sky would be considerably overexposed in relation to the sea. I made a number of exposures, all with quite different effects, over a period of ten minutes or so when the breaks gave way to solid cloud again.

Technical Details
▼ 35mm SLR camera with a 35–70mm zoom lens, neutral-graduated and 81C warm-up filters on Fuji Velvia.

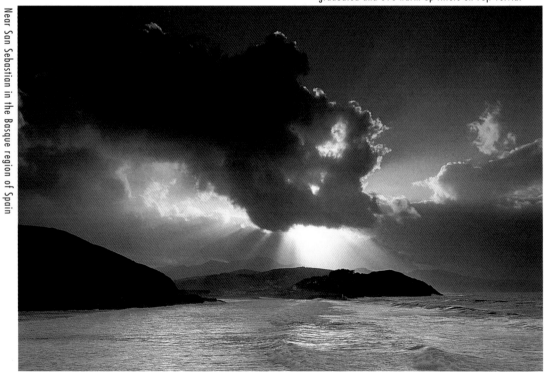

Near San Sebastian in the Basque region of Spain

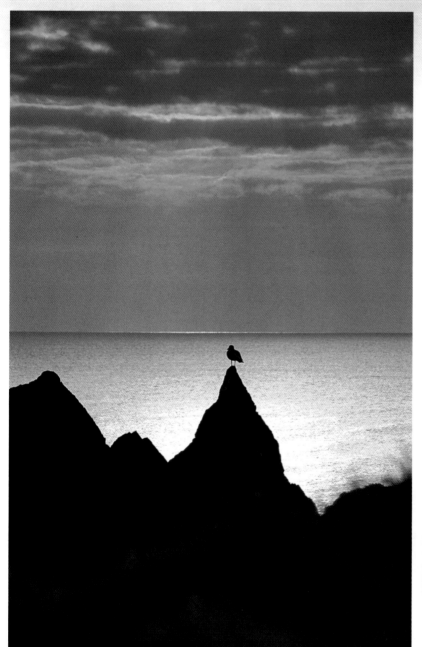

Hartland Quay, North Devon, UK

Julien Busselle spotted this perfectly posed seagull as he was setting up his camera to shoot a seascape. He quickly switched to a long-focus lens and framed the image so that the horizon line divided the image in two and the seagull was almost exactly in the centre. He used a neutral-graduated filter to darken the top of the sky and gave one stop extra exposure than indicated to allow for the brightly lit sea, bracketing half a stop each side.

See how the impact of the image would have been lessened by framing the shot with the seagull placed on the intersection of thirds.

▲ Technical Details
35mm SLR camera with a 75–300mm zoom lens and a neutral-graduated filter on Fuji Velvia.

Mountains & Uplands

For landscape images with a more dramatic quality, the steep contours and rugged nature of mountain scenery offers enormous potential, providing images with strong textures and a rich range of tones. Not only is the landscape itself very different in both appearance and mood but its very nature can also provide the photographer with unusual and less familiar viewpoints.

Seeing

In early spring, the fresh green vine leaves create a powerful colour and the monochromatic effect heightens the pattern of the hillsides.

Thinking

I was shooting towards the light and the sky was hazy, creating a blank, featureless tone. I needed to find an additional feature or detail to give the image a focus of attention.

Acting

By driving a little further up the mountain road, I found that I was able to place this small path and stone hut at the bottom of the frame in a way which allowed me to use a long-focus lens to emphasise them, as well as eliminating the sky. I used a polarising filter to increase the colour saturation and an 81C warm-up filter to enrich the green foliage.

Near Banyuls in the Roussillon region of France

A wider view of the scene, showing more of the sky and foreground, would have been far less effective.

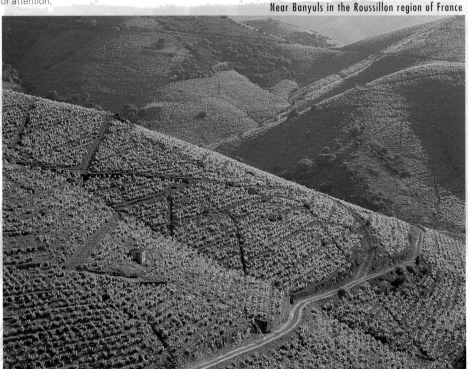

Technical Details

6 x 4.5cm SLR camera with a 55–110mm zoom lens, 81C warm-up, neutral-graduated and polarising filters on Fuji Velvia.

Technical Details
▼ 6 x 4.5cm SLR camera with a 105–210mm zoom lens, 81C warm-up and polarising filters on Fuji Velvia.

Near Torla in the Ordesa National Park in Huesca, Spain

The lighting in this scene created a rich range of tones and the sparkle on the river and highlighted sheep provided a strong focus of attention. I used a polarising filter to increase the colour saturation, and to subdue the highlights on the water, an 81C warm-up filter to eliminate a potential blue cast and a neutral-graduated filter to darken the top area of the sky.

Rule of Thumb

As on the coast, the light at high altitudes has a strong presence of ultraviolet light and warm-up filters are often essential to overcome potential blue casts. Atmospheric haze can also be a problem in the mountains and a polarising filter will often help to give greater clarity in distant views.

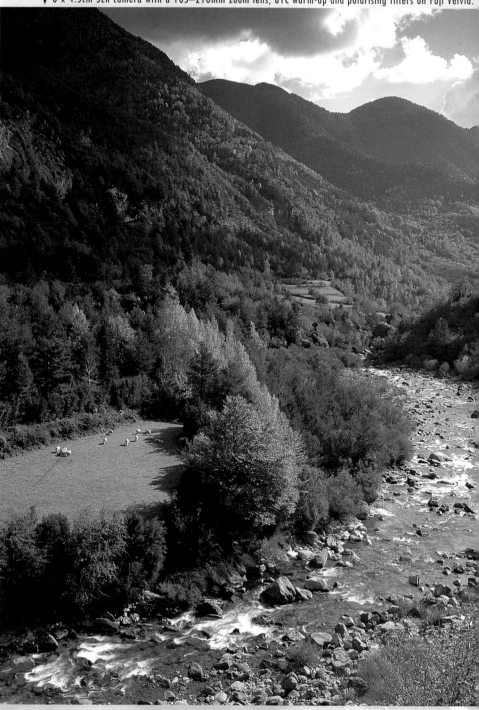

Mountains & Uplands

Seeing

I had been travelling along a small valley and as the sun had disappeared some while before I assumed that my photography for the day was over. As I turned the corner I saw that a lingering shaft of sunlight had created this striking red tip on the snow-covered mountain top.

Thinking

I had to find a viewpoint, stop and set up very quickly as I could see that the effect would last for only a moment.

Acting

I was very lucky to find a track which led up on to a small terrace – the village rubbish dump, in fact – and managed to shoot two or three frames before the sunlight was extinguished. I used a long-focus lens to isolate a small area of the distant scene and underexposed by about two-thirds of a stop to increase the saturation of the red-tinted snow and to make the blue-shaded mountains a darker tone than appeared visually.

The Massif des Ecrins near Grenoble in the Isere region of France

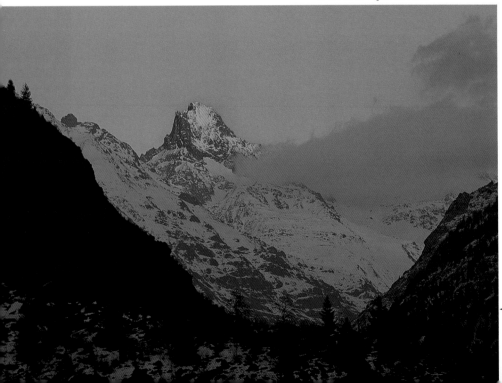

Technique

It's quite probable that you will find viewpoints from where there is a potentially good photograph but that the sun is in the wrong position. Reconnaissance can be a very useful part of landscape photography and you should develop the habit of making a note of such locations on your map. I mark them with a highlight pen and use a compass to calculate when the best time to return might be.

Technical Details

6 x 4.5cm SLR camera with a 105–210mm zoom lens on Fuji Velvia.

▲ Technical Details
35mm SLR camera with a 75–300mm zoom lens on Fuji Velvia.

The Val d'Aran near
Arties in the Lerida
region of Spain

There had been a
fall of snow and the
remaining clouds
had begun to clear,
allowing small
highlighted areas to
appear on the
landscape. I framed
the image tightly to
exclude the sky and
focus attention on
the small barn.

Heath, Marsh & Moorland

What the flatter countryside of heath, marsh and moorland may lack in terms of dramatic contours it can often make up for with its moods of mystery and solitude. It's a landscape in which you need to look carefully for good viewpoints and make use of foreground interest as well as being aware of the effects which can be created by atmospheric lighting.

Seeing

It was midwinter when I saw this scene and was attracted by the subdued colours and rich textures of the dead grass and heather. I also like the swirly effect of the wintry clouds and the hint of colour in them created by the low angle of the sun.

Thinking

I felt that some foreground interest would give another element and a feeling of depth to the picture and found this cluster of rocks did the trick, while the inclusion of a small part of the curving road created a useful focus of interest.

Acting

I chose a viewpoint quite close to the rocks to accentuate the perspective effect and also to hide some of the road, which I didn't want to be too dominant. I used a wide-angle lens to frame the image, an 81B warm-up filter to eliminate the possibility of a blue cast and a neutral-graduated filter to make the tone and colour of the sky a little richer.

Technical Details
▼ 6 x 4.5cm SLR camera with a 55–110mm zoom lens, 81B warm-up and neutral-graduated filters on Fuji Velvia.

The moors near Askrigg in the Yorkshire Dales, UK

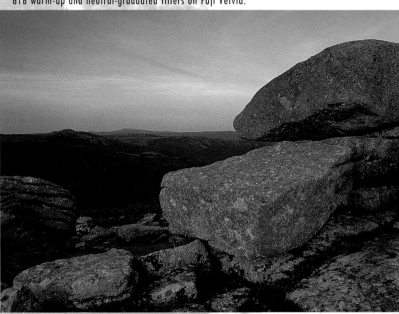

Dartmoor in South Devon, UK

Late afternoon sunlight had created a very pleasing colour and texture on this group of rocks, a small Tor. I framed the image quite tightly as I wanted to emphasise the very attractive quality of light on the rocks and much of the rest of the scene was in shadow. I used a neutral-graduated filter to darken the top area of the sky and an 81B warm-up filter to accentuate the effect of the warm light.

Technical Details

▼ 6 x 4.5cm SLR camera with a 50mm wide-angle lens, 81B warm-up and neutral-graduated filters on Fuji Velvia.

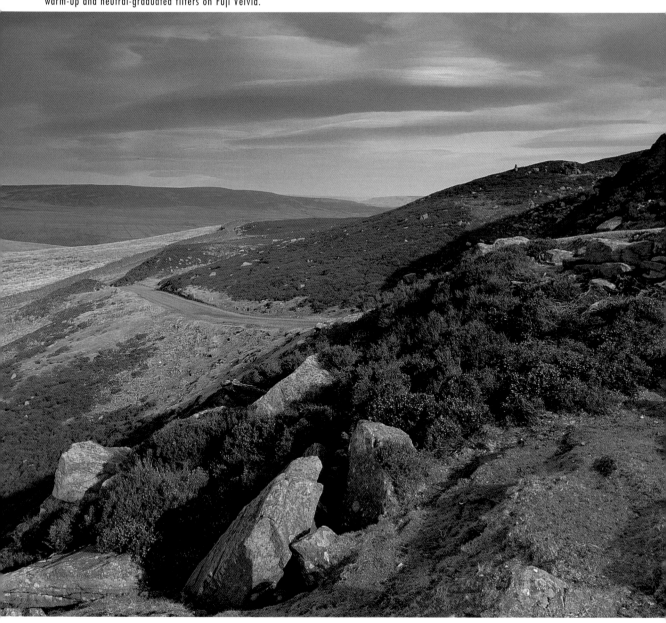

Heath, Marsh & Moorland

Technique

When shooting **sunset pictures** where the sun, or an area of very bright sky, is included in the frame it is best to take an **exposure reading** from the area just above or to the side of it to avoid the risk of underexposure.

Technical Details

▼ 6 x 4.5cm SLR camera with a 105–210mm zoom lens on Fuji Velvia.

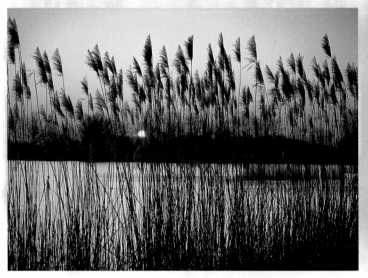

The Dombes region near Bourg-en-Bresse, France

Although this is a very appealing and atmospheric region, it is, nevertheless, rather flat and featureless and its main attractions are the numerous reed-fringed lakes. I shot this scene in winter and used the fairly weak setting sun as the main focus of interest, and the row of reeds as a decorative foreground, shooting on a long-focus lens to minimise the effect of perspective and to give the image a strong graphic quality.

Bell Tor on Dartmoor in South Devon, UK

Technical Details
6 x 4.5cm SLR camera with a 50mm wide-angle lens on Fuji Velvia.

Lakes, Rivers & Waterfalls

Whether dark and mysterious or pale turquoise and crystal clear, whether rushing or motionless, sparkling or turgid, water, in all its natural forms, has a constantly changing appearance which offers considerable photographic potential. The presence of water in a landscape photograph can not only add an element of interest and atmosphere to an image but it can also increase the contrast and add sparkle to a scene on a hazy or overcast day, when the lighting may otherwise be too soft for a successful photograph.

Seeing

I had travelled around this lake during the day looking for pictures but it's a rather **featureless expanse** of water and I felt my best chance of an interesting image was when the sun set or at dusk. For this reason I was keen to find some details or objects which would make an **interesting foreground** when I saw this partially submerged tree.

Thinking

I decided to return at the end of the day with the intention of shooting at sunset. In fact I did so, and it was quite spectacular, but I waited for half-an-hour or so **afterwards** to find that the sky produced this more **subtle** and very appealing pinky blue hue which was nicely reflected in the still water.

Acting

I chose a **viewpoint** which placed the most attractive area of the sky behind the tree and framed the image so there was only a **small strip of shore** visible and the tree was quite large in the viewfinder.

Technical Details

▼ 35mm SLR camera with a 35–70mm zoom lens, 81C warm-up and neutral-graduated filters on Fuji Velvia.

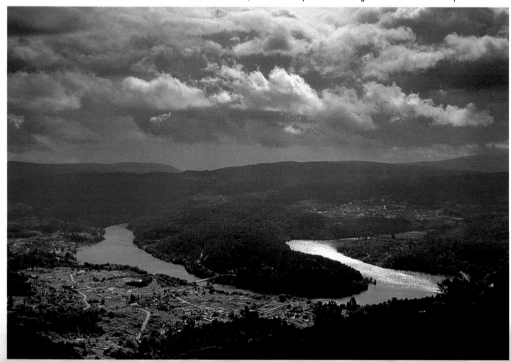

The River Mino near Pontevedra in Galicia, Spain

This was, as you can see, a very cloudy, overcast day but as I drove up out of the river valley this break in the cloud occurred, allowing a small spotlight of sunshine to play on the river. It provided a vital element of contrast for this shot, without which the image would have been flat and uninteresting. I used a neutral-graduated filter to prevent the bright parts of the sky from overexposing.

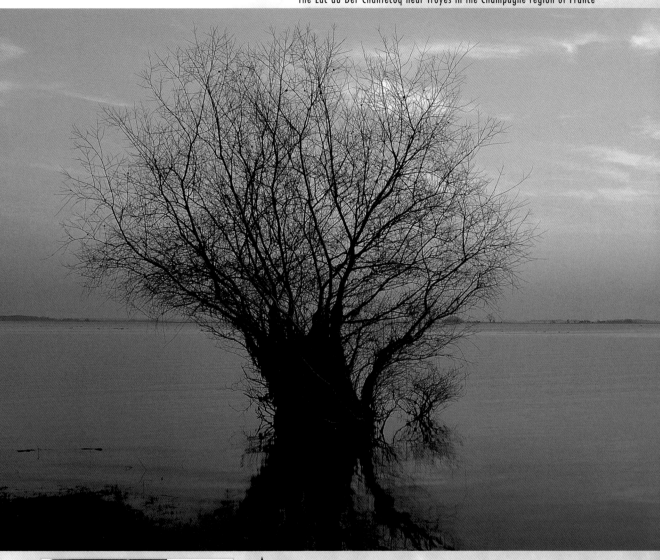

▲ **Technical Details**
6 x 4.5cm SLR camera with a
55–110mm zoom lens on Fuji Velvia.

Square filter systems are more
practical and controllable than
screw-on versions. Here a square
filter holder secures a neutral-
graduated filter.

Rule of Thumb

A polarising filter can be especially
useful when photographing still water
as it can often help to increase the
strength of reflections of the sky or
surrounding details. It is also very
effective in controlling the brightness
of highlights created on back-lit water.

Lakes, Rivers & Waterfalls

Seeing

It was a dull, overcast winter's day when I visited this valley – in fact, it was raining and I had been unable to find any suitable subjects so far. But this waterfall had a very attractive quality in the soft light and the water was flowing well.

Thinking

It was a classic situation for the slow-shutter-speed technique as I was sure that the moving water combined with the soft lighting would create a particularly nice effect.

Acting

I chose a viewpoint and framed my shot so that the water created a Y shape and appeared to flow directly towards the camera and, at the same time, excluded all extraneous details. I used a polarising filter and a small aperture which allowed me to use an exposure of several seconds.

Technical Details
6 x 4.5cm SLR camera with a 105–210mm zoom lens on Fuji Velvia.

The Aysgarth Falls in the Yorkshire Dales, UK

This was taken in midwinter and the river was in full flood, along with many others in the region. I liked the monochromatic effect created by the back-lighting and decided to use a long-focus lens to limit the image to the most dramatic section of the cascading water, using just part of the foreground tree as a sort of frame. I set a fast shutter speed to record the water with a degree of texture.

Technical Details
6 x 4.5cm SLR camera with a 105–210mm zoom lens, 81B warm-up and polarising filters on Fuji Velvia.

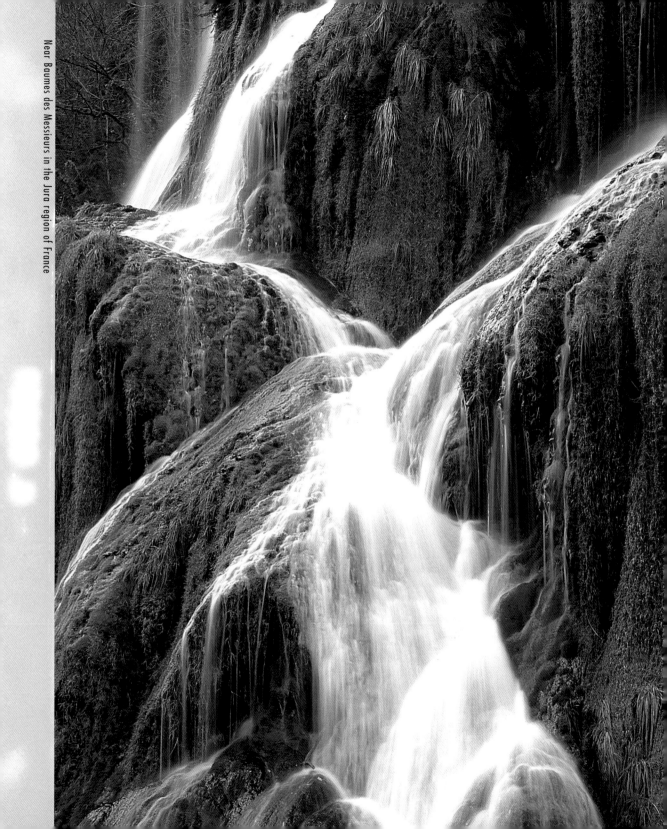

The tree is a crucial element in landscape photography for a number of reasons. Landscape images tend to be dominated by essentially horizontal lines — those of the contours of the land and the horizon — and the vertical line created by a tree often provides both an arresting element of contrast and a powerful focus of attention. Woods and forests also have enormous pictorial potential when viewed both as a broad vista and when seen as a source of closer images in which elements like shape, texture and pattern can be exploited to the full.

Seeing

It was late evening, on what had been an overcast day, when I saw this plantation of young poplar trees. The light level was very low and this seemed to give the autumnal foliage an almost fluorescent glow.

Thinking

I decided that the most effective image would be produced by emphasising the element of pattern which was created by the orderly planting and realised this would be further accentuated by the monochromatic quality of the image.

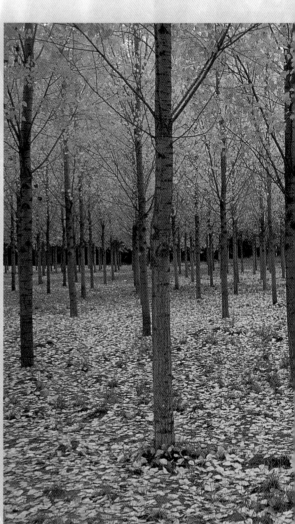

Near Soria in Castile Leon, Spain

Seal Chart Woods near Sevenoaks in Kent, UK

A misty day can be perfect for woodland photography because it simplifies the image and masks unwanted background details. I used a close viewpoint and framed this tree quite tightly to ensure the tree stood out clearly from the misty background and used an 81B warm-up filter to eliminate a potential blue cast and to emphasise the autumnal colours.

Technical Details
6 x 4.5cm SLR camera with a 55–110mm zoom lens and an 81B warm-up filter on Fuji Velvia.

▼ 35mm SLR camera with a 35mm perspective-control lens on Fuji Velvia.

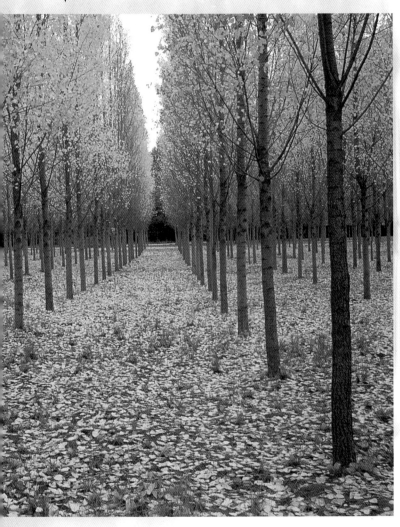

This diagram shows how the tree trunks would have appeared to converge had the camera been tilted down instead of using a shift lens.

Acting

The only feasible viewpoint was from the roadside bank which was at a higher level than the floor of the plantation. I felt it was vital to retain the parallel tree trunks but I also needed to include the base of the nearest trees, which would have meant tilting the camera down and creating converging verticals so I used my perspective-control lens to overcome this. I used a small aperture to obtain maximum depth of field.

Rule of Thumb

The photographic possibilities provided by trees, both individually and collectively, are often at their greatest in the winter months when the absence of foliage reveals the intricate shapes and patterns of bare branches.

Seeing

It was actually raining when I saw this scene and the light was very poor. These lighting conditions often intensify colours like this autumnal foliage and can be far more effective than a bright sunny day.

Thinking

I felt I needed to frame the image quite tightly so that both the colour and the pattern created by the leaves in the foreground would be emphasised.

Acting

My viewpoint was from the far bank of the small lake and I needed to use a long-focus lens to compose the image in the way I wanted. I found that the addition of a polarising filter and an 81C warm-up filter produced a dramatic increase in the richness and saturation of the autumn colour.

Technique

To take a series of photographs of a specific tree or group of trees from the same viewpoint at intervals through the course of a year can be a very satisfying and fascinating way of building a collection of photographs.

Technical Details
6 x 4.5cm SLR camera with a 55–110mm zoom lens on Fuji Velvia.

Near Cognac in the Charente region of France

It was the essentially monochromatic quality of the fresh green spring foliage which appealed to me in this scene as I drove through the valley of the River Charente. The pattern created by the tree trunks was also a powerful element in the composition and these two qualities enhanced each other. I used a long-focus lens to isolate a small area of the scene from a quite distant viewpoint.

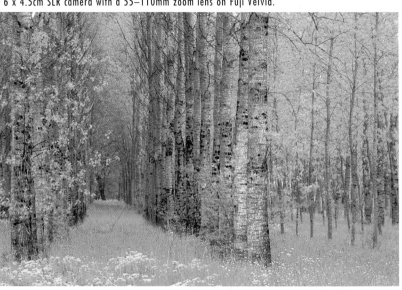

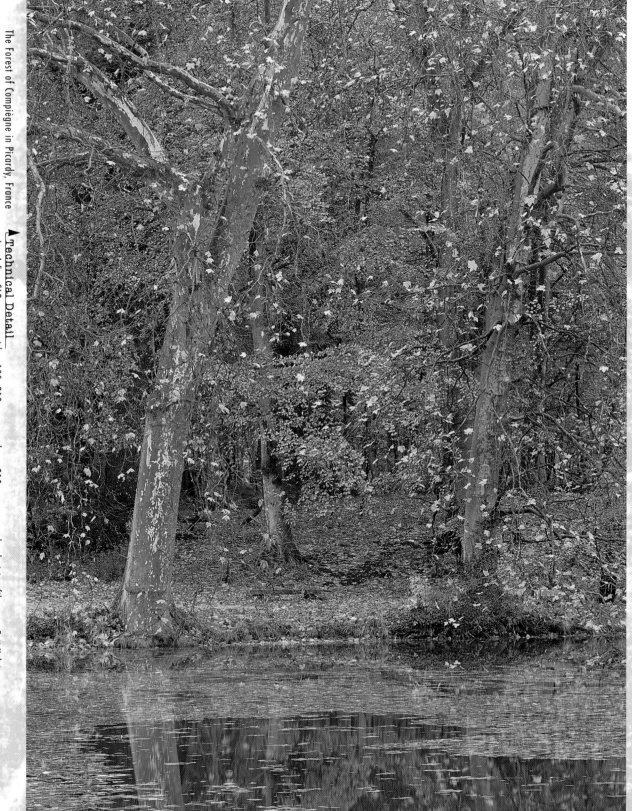

The Forest of Compiègne in Picardy, France

▲ **Technical Detail**
6 x 4.5cm SLR camera with a 105–210mm zoom lens, 81C warm-up and polarising filters on Fuji Velvia.

The Human Imprint

While the appeal of wild and untamed land can be very strong for the landscape photographer, it can in some ways be easier – and sometimes more satisfying – to seek images in countryside where the mark of man is visible. The presence of agriculture and land cultivation, for example, can create a sense of order and structure within the landscape, while both buildings and people can create a powerful focus of interest in a scene.

Seeing

This is a place I've **visited several times** before. On this occasion I was driving through the countryside on a winter's morning when a **hard frost** had carpeted the landscape and created a soft, pastel, almost monochromatic quality.

Thinking

It's generally a very flat region and I needed a **higher viewpoint** to have an overview of the landscape. There is a ridge of low hills where the vineyards are planted and I followed a track up to this viewpoint.

Acting

The picture I'd envisaged was simply not there as the patchwork fields on the plain were too far away and I was still not really high enough. However, I really like the effect the bare vines created and this little stone hut created a perfect **focus of interest**. I tried several ways of **framing the image**, some with the horizon visible and some with closer foreground details but this is the shot I liked best. I used 81A warm-up and polarising filters to increase the colour saturation and to make the sepia tones of the vineyards a little richer.

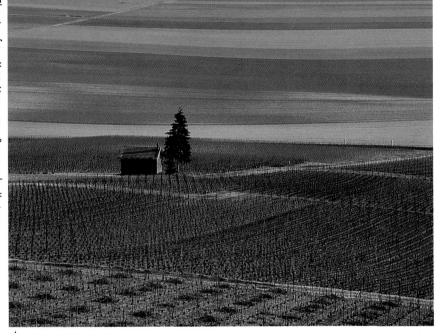

The view from Mont Aimee, near Bergeres-les-Vertus in the Champagne region of France

▲ Technical Details
6 x 4.5cm SLR camera with a 105–210mm zoom lens, 81A warm-up and polarising filters on Fuji Velvia.

Technical Details ▶
6 x 7cm SLR camera with a 180mm lens, 81B warm-up and polarising filters on Fuji Velvia.

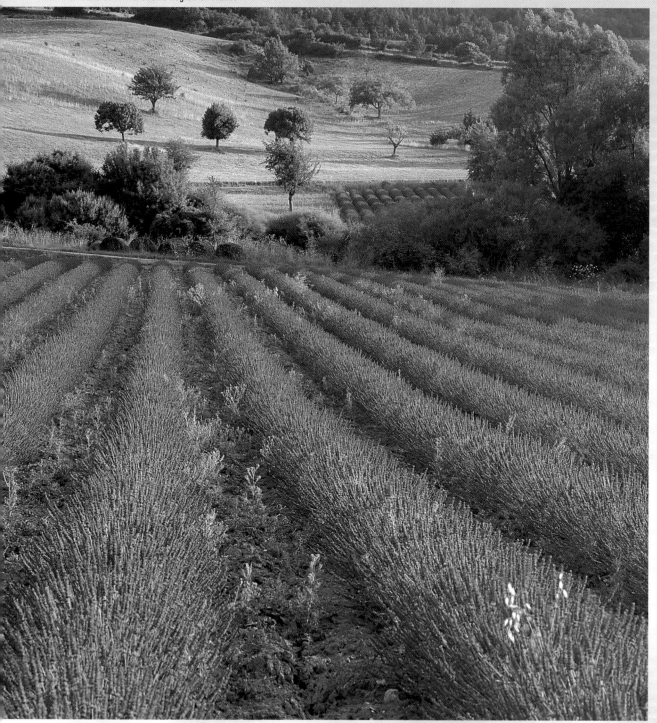

This shot was taken in early evening light when the sun was low. The lavender field was in full bloom and I was able to find a viewpoint where the rows led away from me – the most effective angle – and towards the highlighted field in the distance which created a valuable focus of interest.

Seeing

This shot was taken half-an-hour or so after that of the lavender field on the previous page. The field of sunflowers was the obvious attraction but the effect created by the back-lighting added enormously to the mood of the shot and to the quality of the yellow flowers.

Thinking

I found a viewpoint which placed a particularly dense area of the sunflowers in front of the distant tree and from where the lighting had a strong effect. I needed to eliminate the sky as shooting into the light would make it record as a pale bleached-out tone with no colour.

Acting

I needed to use a long-focus lens to frame the image quite tightly and also to minimise the perspective effect and compress the colour of the sunflowers. I used an 81B warm-up filter and a polariser to increase the colour saturation and a neutral-graduated filter to darken the area of more brightly lit hillside at the top of the frame.

Near Ferrassieres in the Drôme region of France

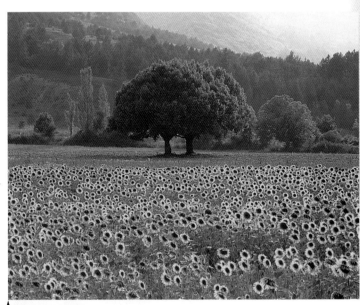

Technical Details

6 x 7cm SLR camera with a 250mm lens, 81B warm-up, polarising and neutral-graduated filters on Fuji Velvia.

Near Cheltenham in Gloucestershire, UK

I liked the textural quality the perfectly angled sunlight created on this giant hay bale as well as its shape. I used a close viewpoint and a wide-angle lens to emphasise the effect of perspective, a polarising filter to make the sky a richer blue and to give the clouds greater relief and an 81C warm-up filter to give added warmth to the colour of the hay.

Technical Details
6 x 4.5cm SLR camera with a 50mm lens, 81B warm-up and polarising filters on Fuji Velvia.

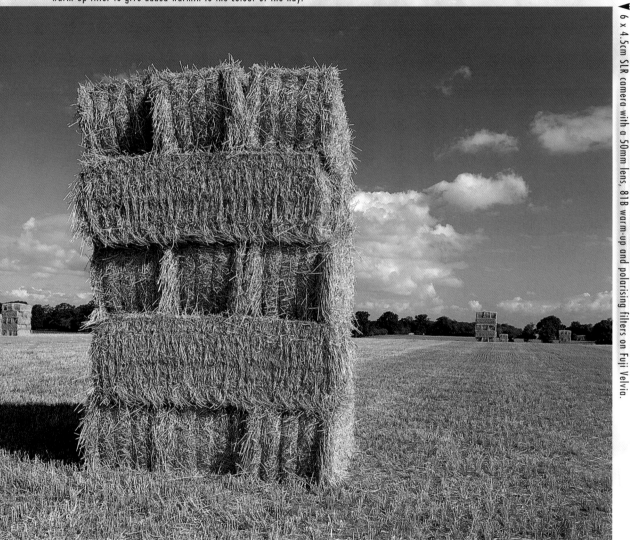

Technique

Land cultivation can be a rich source of images which depend for their appeal upon visual elements such as shapes, patterns and textures – the parallel furrows created on a newly ploughed field, for example, or the striking tracery of pattern and texture produced when newly emerging crops carpet the landscape.

The Urban Landscape

To many people, landscape photography means the great outdoors and the appeal of the open countryside. But, if only from a purely photographic point of view, it can make a refreshing change to look for photographs among the angular forms of buildings instead of the softer contours of the land. Many cities are a fascinating mix of weathered ancient buildings and gleaming new constructions of stainless steel, glass and concrete, and the contrast can be both inspiring and stimulating, especially for those who are more accustomed to photographing the rural scene.

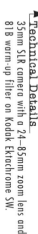

Seeing

It was a quite bleak, wintry day when I visited the Louvre and at first the possibility of an interesting shot of the famous glass pyramid seemed unlikely. But as I walked around it I found that by looking back towards the brightest part of the sky, a quite striking degree of relief was created along with some pleasingly soft and subtle colours.

Thinking

I felt that to shoot the pyramid alone might not produce an image with enough contrast and so I looked for a way of introducing a darker foreground.

Acting

I walked to the far side of the pool behind me and found that from there I could include some of the water in the foreground along with part of the fountain and as these were both in shadow they provided an effective darker-toned frame to the image of the pyramid. Then all I had to do was wait for a gap in the stream of people passing between the pool and the pyramid.

Technical Details
35mm SLR camera with a 24–85mm zoom lens and 81B warm-up filter on Kodak Ektachrome SW.

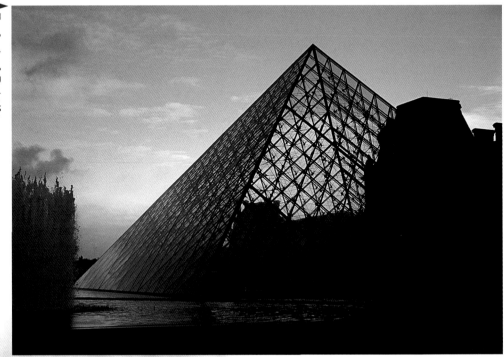

The courtyard of the Louvre Museum in Paris, France

Bear in mind that your choice of viewpoint will often have a significant effect on the way in which a scene is lit as well as altering the composition.

San Francisco, USA

I found this viewpoint of the typically steep streets of this city and although it was a day on which the lighting was not ideal, from here the sun was glancing off some of the buildings, giving the scene a rather surreal quality. I decided to use a long-focus lens to frame the most strongly-lit part of the image and refrained from using a warm-up filter so the image would have this curious blue-grey quality.

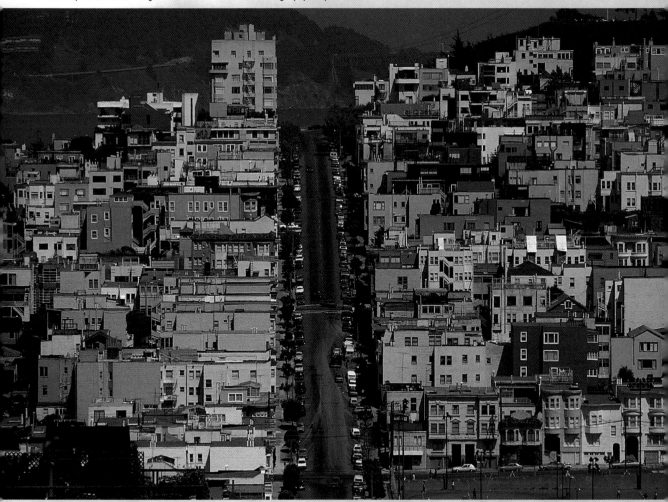

▲ Technical Details
35mm SLR camera with a 200mm lens on Kodachrome 64.

Rule of Thumb

If they are illuminated, city streets and buildings will often look more interesting when shot at night than they do in daylight and this can also be a very useful way of masking problems like crowds of people, parked cars and street signs.

Seeing

This steel and glass building, like many others, has much **photographic potential**, but I wanted to avoid the more obvious shot of its facade so I walked around and inside the complex looking for a viewpoint which would give me a rather more **ambiguous** image of the structure.

Thinking

I liked this **viewpoint** which enabled me to use this exterior lift shaft and archway as a foreground and **frame** for the more distant building.

Acting

I needed to use a **wide-angle lens** to frame the image in the way I wanted while still including enough of the structure. I calculated my exposure so that the foreground details were **silhouetted** and waited until the lift and some passengers reached the ideal point in the frame before shooting.

Technical Details
▼ 6 x 4.5cm SLR camera with a 20–35mm zoom lens on Fuji Velvia.

Tokyo, Japan

I shot this image from a high-rise building through a window by placing the camera lens as close to the glass as possible. I waited until I felt that the scene had become dark enough to allow the illuminated buildings to record quite brightly but before the sky became completely black.

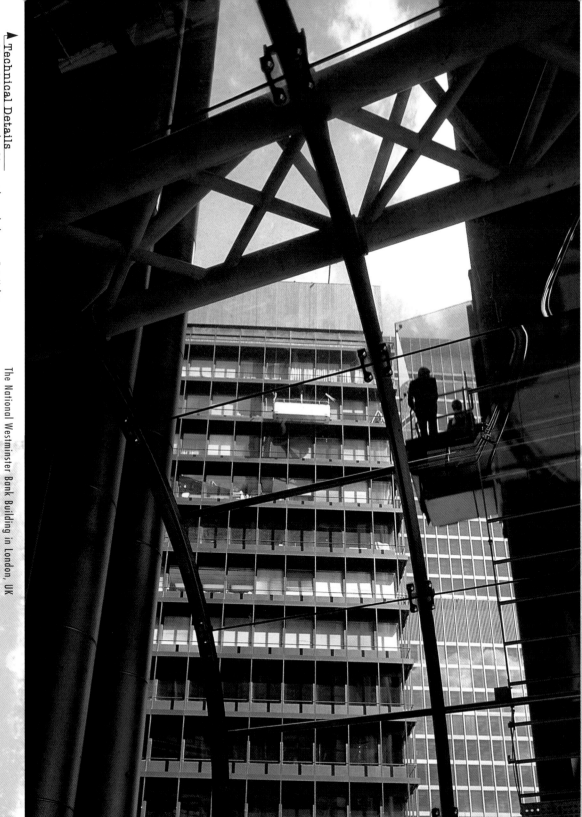

▶ Technical Details
35mm SLR camera with a 20mm wide-angle lens on Fuji Velvia.

The National Westminster Bank Building in London, UK

The Art of Composition

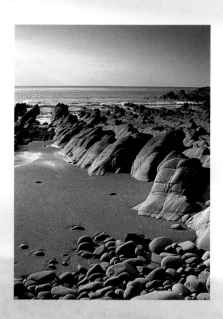

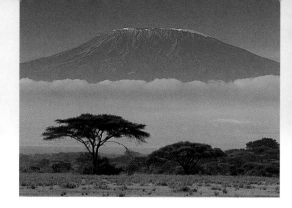

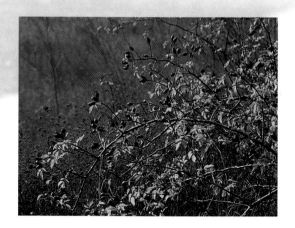

2

The art of composition involves
organising the elements of a scene
within the camera's viewfinder in the most telling way. With subjects like still lives and
portraits the subject itself can be organised but with landscape photography the composition
can only be altered by the choice of viewpoint and the way in which the image is framed.

The Importance of Viewpoint

The ability to select a particular aspect of a scene, and to arrange it in the most pleasing way, is largely dependent upon the choice of viewpoint, and this is one of the most important decisions a photographer can make before taking a photograph. Many inexperienced photographers will shoot their pictures from the place where they were first aware of a potential picture but, when time allows, it pays to explore all the possibilities before making your exposure.

Seeing

This is one of the most photogenic sections of the Tarn Gorges which are quite **difficult** to photograph in a way which suggest the **sheer spectacle** of the river. At this point a platform has been provided for tourists to enjoy the view and the raised viewpoint does help to create a much more **dramatic perspective** of the gorge than is possible from the river bank.

Acting

I can claim very little credit for the sheer luck of finding this very **atmospheric lighting** on this visit to the river, and I have visited the same spot several times since and never found anything like as interesting. I needed to use a **wide-angle lens** to frame the image in the way I wanted and used an 81C warm-up filter to offset a potential blue cast. I also used a **polarising filter** to increase the colour saturation and to subdue the highlights on the water, as well as a neutral-graduated filter to prevent the bright sky from overexposing.

Thinking

The risk with using viewpoints like these is that you finish up with the same, often rather bland, **snapshot** which everyone else who visits the site has taken.

The Gorges of the River Tarn near Millau in the Midi Pyrenees region of France

Near Merida in the Extramaduran region of Spain

This photograph was taken on a very grey, overcast day but my attention was caught by the mass of white and purple wild flowers below the oak trees. I chose a viewpoint which placed the most concentrated area of colour in front of a group of trees where no daylight was visible between them, as this would have diluted the effect of the colour. I framed the shot tightly using a long-focus lens to exclude unwanted details, especially the sky which was white and featureless.

▲Technical Details
35mm SLR camera with a 75–300mm zoom lens and an 81B warm-up filter on Fuji Velvia.

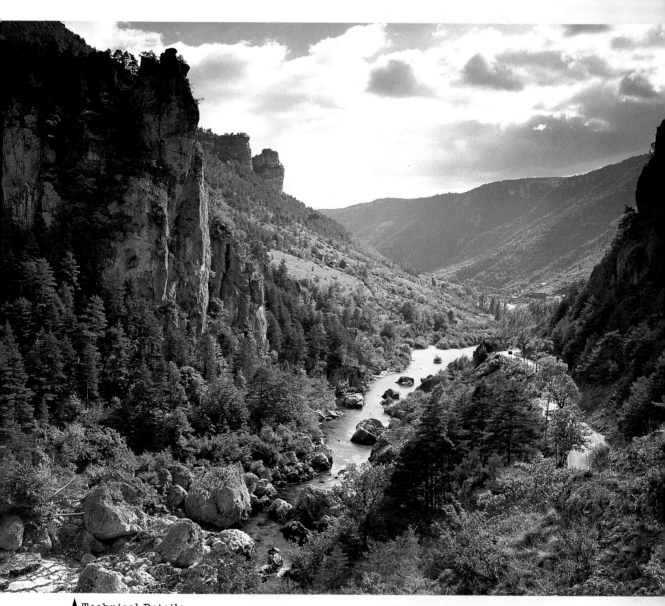

▲ Technical Details
6 x 4.5cm SLR camera with a 50mm wide-angle lens, 81C warm-up, polarising and neutral-graduated filters on Fuji Velvia.

The Importance of Viewpoint

Seeing

I'd driven up this mountain road looking for a place which would give me a good view of the mountain range on the other side of the valley and thought that somewhere at this height would be fine.

Thinking

It was a sunny but hazy day and the lighting was less than crisp. Consequently, although the snow-covered mountain-top was well-defined against the sky, the green slopes below were rather flatly lit and lacked any real bite.

Acting

I looked around for some possible foreground interest which might add an element of colour or contrast and found this clump of grasses and yellow flowers. I had to use a very close viewpoint as I wanted to see over the foreground into the valley below to heighten the feeling of depth and distance. I used a wide-angle lens to include enough of the foreground and the sky and set a small aperture to ensure adequate depth of field.

See how a more distant viewpoint would have caused the tree to mask the crucial area of the mountain.

The red rocks are the most striking feature of this mountain range and on this occasion the late afternoon light was creating quite bold relief and enhancing their colour. I thought that the twisted pine tree would provide both an interesting foreground and a useful element of contrast for the rocks and blue sky but I found that to use the tree as a frame and to see the top of the mountain I had to use a very close, low viewpoint which required the use of a wide-angle lens in order to include enough of the scene.

The Esterel Massif near St Raphael in the Var region of France

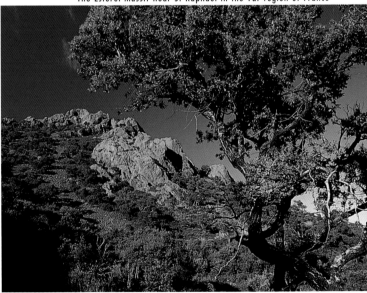

Technical Details

35mm SLR camera with a 20–35mm zoom lens, 81C warm-up and polarising filters on Fuji Velvia.

Near Barcelonette in the Haute Alpes region of France

▲ Technical Details
6 x 4.5cm SLR camera with a 50mm wide-angle lens, 81C warm-up, polarising and neutral-graduated filters on Fuji Velvia.

Framing the Image

The camera's viewfinder should be considered as the equivalent of a painter's blank canvas. While a photographer has far less control over the details included in the viewfinder it is, nevertheless, his choice and only by making the best choices are the most telling images created. Be aware of any details which are distracting or unpleasing to the eye and if they cannot be eliminated or minimised acceptably by the choice of viewpoint and the way the image is framed, the best solution may well be not to take the picture as it will almost certainly disappoint.

Seeing

For these two photographs Julien Busselle explored a number of ways of framing the image. In the first instance it was the almost unreal quality which the sunlight created on the sculpted rocks which appealed to him and he decided to frame the image so that just this group of rocks were featured in the photograph.

Thinking

Julien became more aware of the possibilities of including closer foreground details in the image and also allowing the distant sea and horizon to come into the top of the frame.

Acting

He moved to a more distant viewpoint, changed the horizontal format to an upright and then widened the setting on his zoom lens to include the additional details he wanted. He used a polarising filter to increase the colour saturation of the sand and to control the bright highlights on the sea and an 81B warm-up filter to eliminate the possibility of a blue cast.

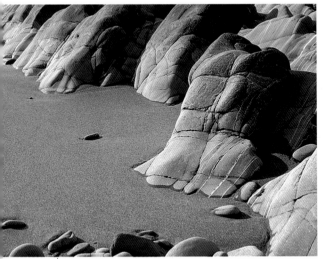

▲ Technical Details ➤
6 x 4.5cm SLR camera with a 55–110mm zoom lens, 81C warm-up and polarising filters on Fuji Velvia.

Technique

Many inexperienced photographers use a camera's viewfinder like a gun sight, concentrating on the centre of the image and being only vaguely aware of the other details which are included. This often results in the inclusion of unwanted details and a centrally placed focus of interest, which is seldom the best position. It's best to look inwardly from the edges of the frame, so you become more aware of how all the elements of the image relate to each other.

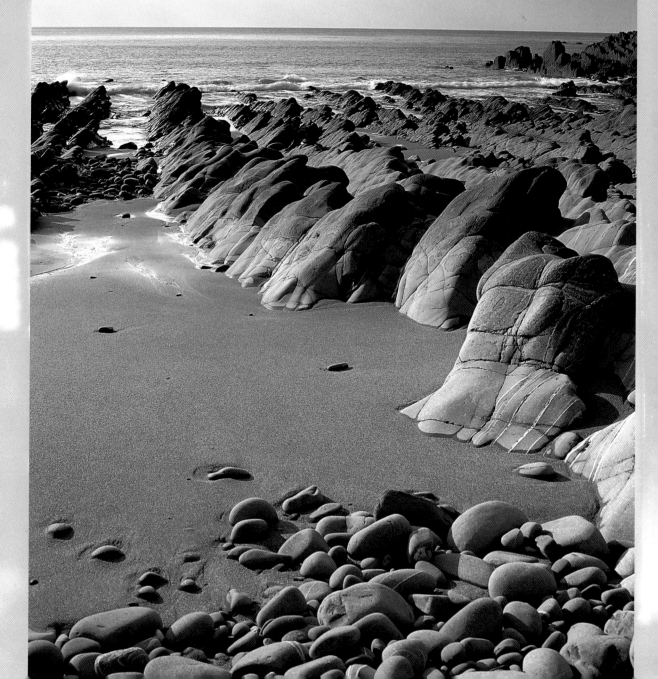

Framing the Image

Rule of Thumb

When deciding how best to frame a shot it is first necessary to identify the main focus of attention in the scene. This will help you decide how much more of the scene needs to be included and where the most effective place for this key detail will be within the image.

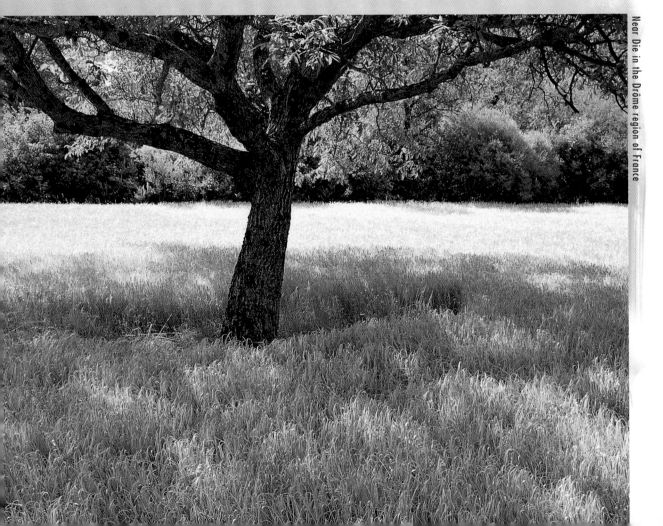

Near Die in the Drôme region of France

Seeing

I came across this lone tree one afternoon when the sun had become low enough in the sky to create some interesting textures on the newly tilled soil. My first instinct was to frame the picture as a horizontal because I liked the curving shapes and contours of the field and I made a few exposures framed in this way.

Thinking

The tree was not completely alone. There was another a short distance to the left of it and to have included this would, I felt, have spoilt the effect of the photograph. In order to exclude it, I had to place my tree rather closer to the edge of the frame than I really felt comfortable with.

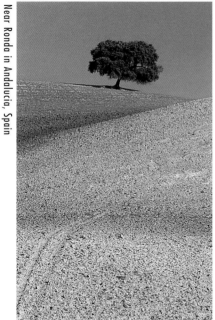

Near Ronda in Andalucia, Spain

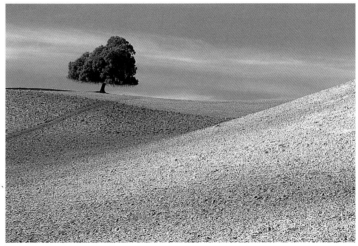

Technical Details
35mm SLR camera with a 35–70mm zoom lens, 81C warm-up and polarising filters on Fuji Velvia.

Acting

I decided to sacrifice the nice sweep of the field and switch to an upright format, framing the image rather more tightly. In this way I could place the tree almost centrally in the top quarter of the frame and I included a large area of the field below to balance it.

There were two main elements which attracted me to this scene – one was the pleasing shape of the tree's spreading branches and the other was the quality of the two dominant colours and the contrast between them. I framed the image to include only the most important details so there was a comfortable balance between the field of grain and the green foliage behind.

Technical Details
6 x 4.5cm SLR camera with a 55–110mm zoom lens, 81C warm-up and polarising filters on Fuji Velvia.

Using Shapes & Patterns

All photographs depend for their effect on a number of individual visual elements, and the most successful photographs are usually those in which one or more of these elements is boldly and clearly defined. The outline or shape of a subject is the element which usually first identifies it, and a photograph with a dominant shape invariably has a strong initial impact. The shape may not necessarily be that of a specific object — it could be simply that which is defined by an area of highlight, shadow or colour. A shape can also be one which is created by the juxtaposition of objects within a scene, such as a line of trees or a cloud formation.

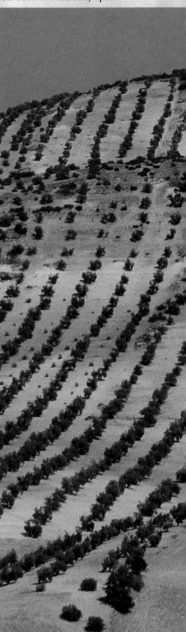

Near Jaen in Andalucia, Spain

Seeing

I was driving down this small valley late on a spring afternoon as the sun was just beginning to set below the top of the steep hill on the opposite side of the valley. I suddenly saw this scene where the two trees almost appeared to be artificially lit.

Thinking

I chose a viewpoint from where the trees were close together but clearly separated and framed the image tightly to exclude the bright sky above the opposite hillside and to give full emphasis to the trees.

Acting

As the sun was shining directly on to my lens and causing flare I needed to use my lens-shield gadget to overcome this. I also used a neutral-graduated filter to ensure the shadow behind the tops of the trees was as dark as possible.

Near Aubenas in the Ardèche region of France

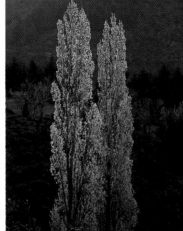

Technical Details ▶

6 x 4.5cm SLR camera with a 105–210mm zoom lens, 81C warm-up and neutral-graduated filters on Fuji Velvia.

This is my lens-shield gadget attached to the camera's accessory shoe.

Technical Details

35mm SLR camera with a 75–300mm zoom lens, 81C warm-up and polarising filters on Fuji Velvia.

It was the near-sepia quality of the sun-bleached Andalucian hillside which appealed to me in this image, combined with the way the pattern of olive trees seemed to echo the curving shape of the hill. I used a long-focus lens to isolate the most effective part of the scene with an 81C warm-up filter to accentuate the warm colour of the soil and a polariser to increase the colour saturation of the rather hazy sky.

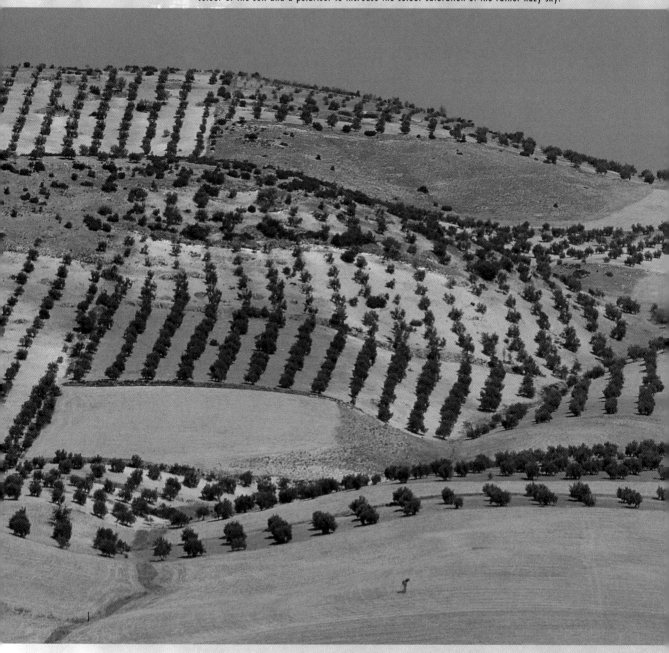

Seeing

This huge mountain is a stunning sight and visible from many places in this part of Kenya. Much of the time, however, its snow-capped peak is **shrouded in cloud** during the day and one of the best chances of seeing it is in the **early morning**. I was staying in a camp near this viewpoint and had seen this nicely shaped isolated tree during the previous day, thinking that it would provide strong additional interest for a shot of the mountain and would create an **effective contrast** to the smooth shape of Kilimanjaro.

Thinking

I got up **long before dawn** on the next day and drove to the spot, delighted to discover that the peak was clear of cloud and that the mist at ground-level made the tree stand out in strong relief.

Acting

I chose a **viewpoint** which balanced the tree comfortably with the bulk of the mountain and used a **long-focus lens** from some distance away to make sure the tree did not seem too large in proportion to it. Then I waited until the rising sun just caught the mountain top and used both polarising and neutral-graduated **filters** to add some strength to the quite subtle tones.

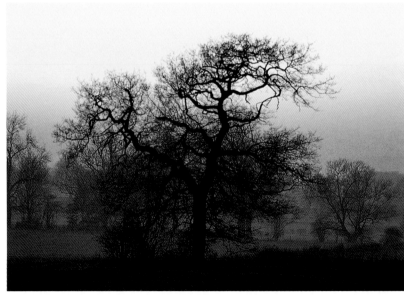

Near Sevenoaks in Kent, UK

Technical Details
35mm SLR camera with an 80–200mm zoom lens, neutral-graduated and polarising filters on Fuji Velvia.

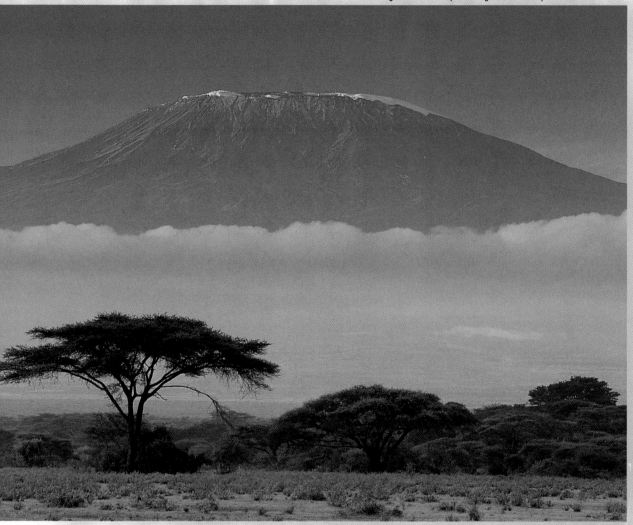

Mount Kilimanjaro seen from Amboseli, Kenya

Technical Details
35mm SLR camera with a 150–500mm zoom lens on Fuji Velvia

I went out one winter's evening to try out a new long-focus lens and saw this distant tree just after the sun had set. I particularly liked the quality which the shapes and patterns of the bare branches had when silhouetted against the bright orangy pink sky. I used my camera's mirror lock and delayed action setting to avoid the risk of camera shake.

Using Perspective

Perspective is the effect created by the diminishing size of objects as they recede from the camera, as you can see when looking down a tree-lined avenue, for instance, or when a small rock in the close foreground appears to be as large as a distant mountain. It is this effect which helps to give an image a sense of depth and distance and also contributes to the impression of solidity and the three-dimensional quality which a photograph can have. An image which has little sense of perspective tends to have a more graphic and painterly quality.

Seeing

It was a perfect summer's day, with a dense blue sky and sharp clear sunlight when I visited this location, one of my favourites. If anything, the lighting was almost too contrasty for some situations but I felt that the quite stark quality would work well with this shot of a chalky track.

Thinking

The two elements which appealed to me were the effect of the track leading away from the camera and the small group of very bright white clouds just above the horizon. Although I think the shot would have worked without it, the small tree near the cloud was a bonus.

Acting

I chose a viewpoint which placed the most dominant cloud more or less on the intersection of thirds and framed the shot using a wide-angle lens, tilting the camera down to include as much of the track in the foreground as possible in order to exaggerate the perspective. I used a polarising filter to make the contrast between cloud and sky as strong as possible and an 81C warm-up filter to offset a potential blue cast.

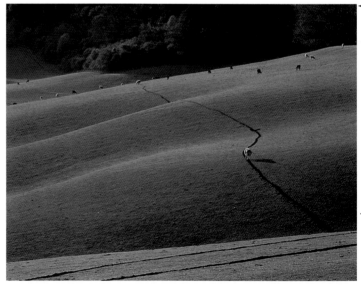

The North Downs near Wrotham in Kent

I saw this picture just before sunset on a summer's evening and was struck by the lovely contoured quality the low sun had created on the rolling downs. I used a long-focus lens to home in on the most well-defined area of the scene which at the same time has given the impression of compressed perspective and framed the image so that the track and lone cow were in the strongest position.

Technical Details
6 x 4.5cm SLR camera with a 300mm lens on Fuji Velvia.

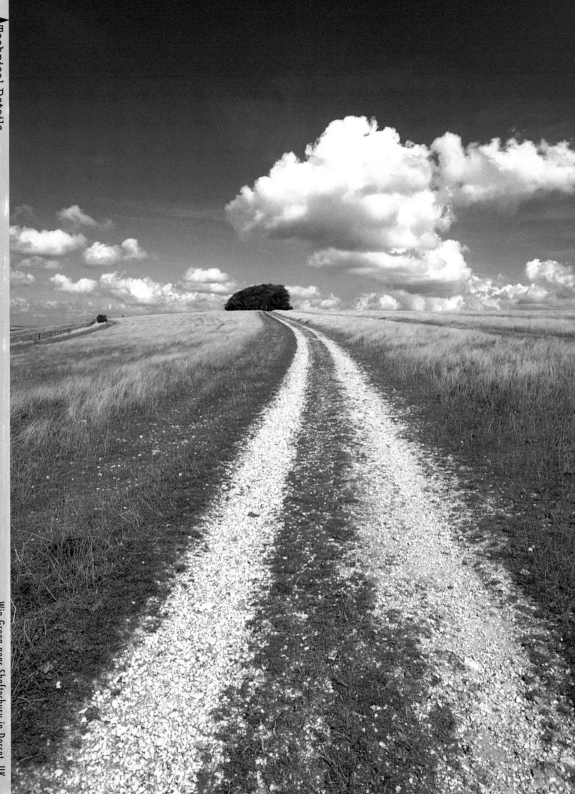

Technical Details
35mm SLR camera with a 20–35mm zoom lens, 81C warm-up and polarising filters on Fuji Velvia.

Win Green near Shaftesbury in Dorset, UK

Technical Details
35mm SLR camera with a 20–35mm zoom lens, polarising and 81EF warm-up filters on Fuji Velvia.

Seeing

In landscape photography, anything which creates a contrast with the dominant colours of blue and green tends to have a striking effect and this rape field caught my eye. The pair of silhouetted trees on the horizon were also a valuable element as were the strong blue sky and white clouds.

Thinking

I still felt the image needed something else to create a really bold image and I thought that including this small section of the rustic wooden fence in the foreground would add interest and heighten the sense of depth and distance.

Rule of Thumb

Because wide-angle lenses enable you to include both very close and far distant details in the same image they have the effect of exaggerating the perspective effect. A long-focus lens, on the other hand, will enable you to eliminate close foreground details and will, accordingly, lessen the impression of perspective.

A spring meadow near Valdepenas in La Mancha, Spain

I spotted this blaze of colour from some distance away but, as is often the case, when I approached the patch of flowers more closely the effect was less dramatic. I decided to use a more distant viewpoint and a long-focus lens to isolate the most striking area of the field and compress the colour effect within the frame. Even if I used a small aperture the depth of field would be limited so I focused on what I felt was the most dominant plane and allowed the other details to be out of focus.

Technical Details
35mm SLR camera with a 300mm lens on Fuji Velvia.

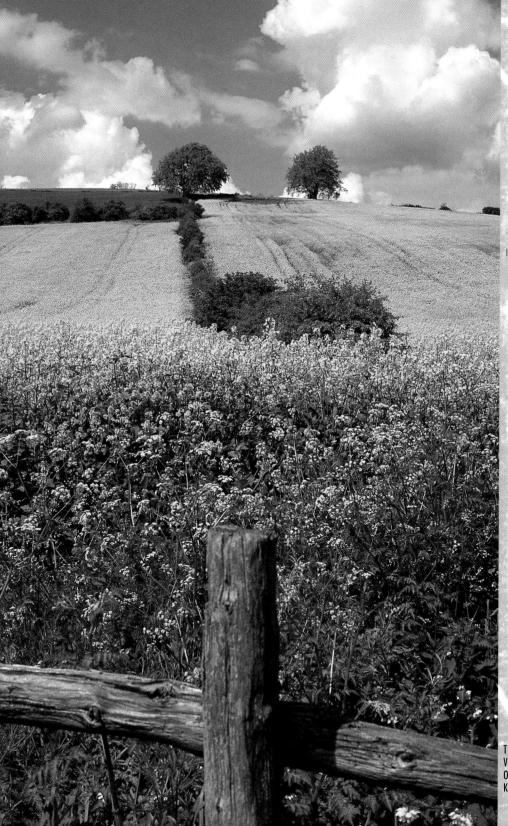

Acting
I used my wide-angle zoom at its widest setting so the fence almost filled the bottom third of the frame and the sky the top third. I used a polarising filter to increase the colour saturation and the relief between clouds and sky and an 81EF warm-up filter to offset a potential blue cast.

The Darent Valley near Otford in Kent, UK

Skies & Horizons

The sky can be a very important element in landscape photography and the position the horizon occupies is likely to be a dominant force in the composition of an image. The standard advice is to place it along a line which divides the image into thirds and as a general rule it should not divide the picture into two equal halves. But a great deal depends upon the nature of the sky and also on details or objects which extend from the landscape into the sky. Ultimately, it is a question of placing the horizon in a way which creates a pleasing balance between all of these elements.

Seeing

I saw this lone tree as I drove along a small country road and it seemed like a potentially **strong image**. It was not until I got out of my car that I saw the solitary cloud above it.

Thinking

I could see that the cloud was both moving and evaporating and realised I only had a **short time** to take my shot. I set up very quickly and chose a viewpoint which placed the cloud more or less directly above the tree.

Rule of Thumb

The sky is invariably proportionately brighter than the landscape below it, because it is, in effect, a part of the light source. When a significant area of bright sky is included in the viewfinder it can cause a degree of underexposure and it is best to take your reading with the camera tilted downwards to exclude the sky.

Technical Details

▼ 6 x 4.5cm SLR camera with a 55–110mm zoom lens, 81B warm-up and polarising filters on Fuji Velvia.

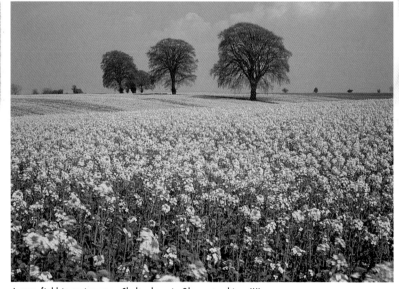

A rape field in spring near Cheltenham in Gloucestershire, UK

I was attracted to the group of trees, just coming into leaf, on the horizon of this shot. I chose a viewpoint which created the best separation between them and used a wide-angle lens to include a large amount of foreground and to emphasise the effect of perspective. I framed the shot so that only a small section of the rather weak sky was included.

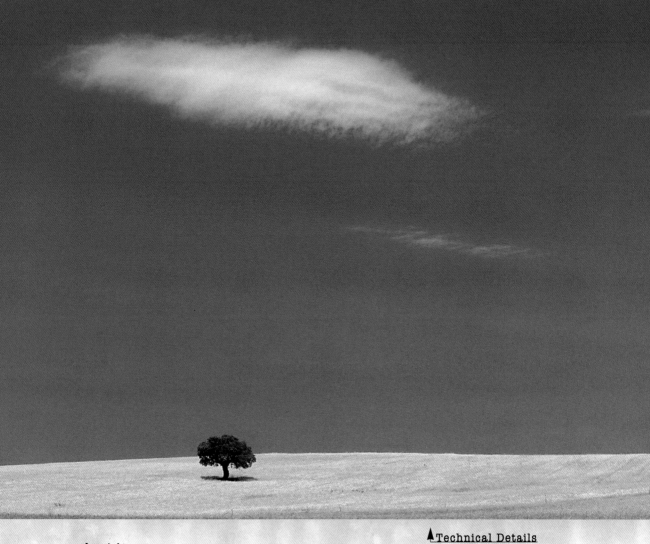

Acting

I framed the image to place the tree slightly off centre and to exclude a fence along the bottom edge of the field and include a small area of sky above the cloud. I used a polarising filter to increase the colour saturation and relief between sky and cloud, and added an 81C warm-up filter to eliminate the risk of a blue cast.

▲ Technical Details
35mm SLR camera with a 35–70mm zoom lens, 81C warm-up and polarising filters on Fuji Velvia.

The banks of the River Gironde near Pauillac in the Medoc region of France

The sky alone was the sole reason for taking this shot. I looked very hard for a suitable foreground to add interest and more strength to the composition but without success. I decided it was worth it anyway and framed the image in a way which allowed the sky to occupy most of the frame and which also placed the small gap in the trees on the distant bank and the reflections in the water in the strongest position as a focus of interest.

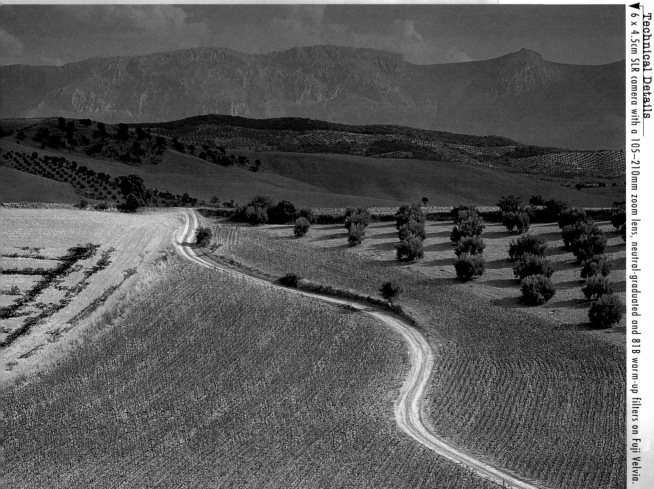

Technical Details 6 x 4.5cm SLR camera with a 105-210mm zoom lens, neutral-graduated and 81B warm-up filters on Fuji Velvia.

The Sierra Magina near Jaen in Andalucia, Spain

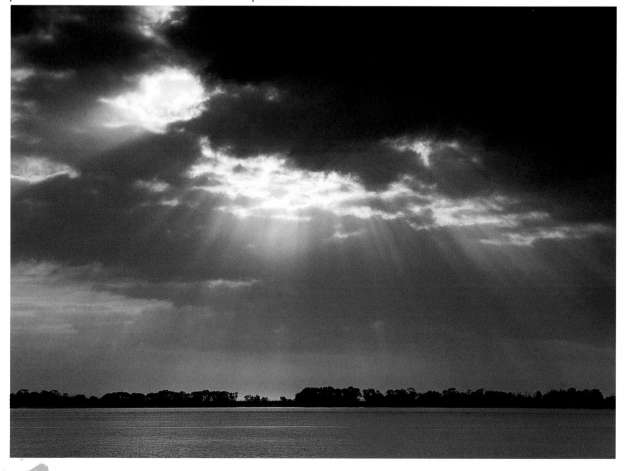

Seeing

It was a late autumn afternoon when I saw this scene while travelling through the northern part of Andalucia where the parched landscape has this almost sepia quality. It was this which appealed to me along with the striking textural effect created by the low angle of the sun.

Thinking

The negative factor was the presence of a rather weak, hazy sky but this was offset to a degree by the fact that the mountain below was in shadow which helped to create sufficient contrast.

Acting

I decided to frame the shot so that only a small area of the sky was included in the image and used a neutral-graduated filter to make both the sky and shadowed mountain as dark as possible.

Technique

If the sky does not make a positive contribution to the image, and there is nothing of importance which rises above it, it is best to consider cropping it out altogether or to include only a very small strip to define the horizon.

Landscape in Close-up

Moving much closer to objects within the landscape can often reveal details of astonishing beauty. Close-up photography can make a textured surface seem as big and important as a distant landscape and it's possible to reveal shapes and patterns in many natural forms, like trees and rocks, which would otherwise pass unnoticed. Taking a much closer view of the landscape can heighten your sense of perception and help you to see new ways of approaching a subject and of composing images.

Seeing

I was initially drawn by the pattern which the lichen created on the rock and the striking contrast it created with the darker tone and texture of the stone and considered using a very close viewpoint to make this the sole feature of the image.

Thinking

When I set up my camera and tripod I became aware of the more striking contrast between the dark greenish colour of the rock and the rust-brown hue of the dead leaves.

Acting

When I looked through the viewfinder and experimented with the viewpoint and framing I found that by cropping the rock in this way and including an equal area of leaves at the side and base of the image it created a quite bold, graphic shape and the colours seemed to enhance each other. I used an extension tube to allow the lens to focus at a close distance.

The Forest of Fontainebleu in the region of Ile de France, France

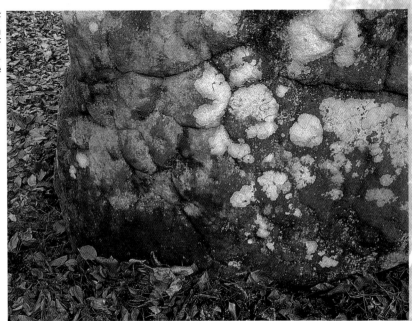

Technical Details ▶
6 x 4.5cm SLR camera with a 55–110mm zoom lens and an extension tube on Fuji Velvia.

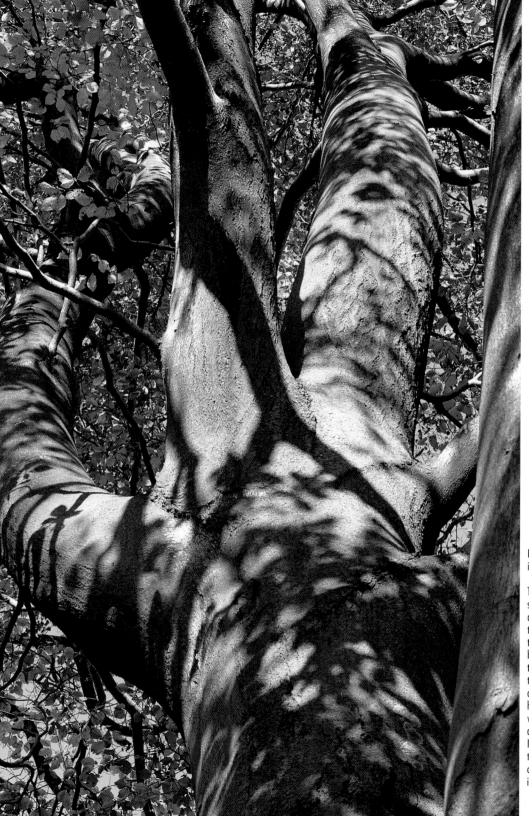

Technical Details
35mm SLR camera with a 35–70mm zoom lens and 81B warm-up filter on Fuji Velvia.

Knole Park near Sevenoaks in Kent, UK

The combination of the shape created by the trunk and twisting branches of this fine old beech tree and the shadows the sunlight had created as it filtered through the foliage made this image work for me. In order to see this clearly I had to use a very close viewpoint, from almost against the tree trunk, and I framed the shot so that the strongest combination of shape and shadow was included in the image.

Landscape in Close-up

Depth of field becomes increasingly limited as the lens is focused at closer distances and it is necessary to use a small aperture for subjects where you want to have the images sharp overall, especially if they are not flat on to the camera.

Seeing

This shot was taken in winter on an overcast day when the light was not creating enough contrast for long-distance landscapes. But this waterfall caught my eye, partly because of its intriguing shape as the water coursed down over the rocks and partly because of the pattern and texture created by the bare branches of the neighbouring trees which were heightened by the monochromatic quality of the scene.

Thinking

I needed to make the waterfall quite big in the frame and I also wanted to exclude much of the surrounding details and concentrate attention on this area where the most striking shapes and textures were concentrated.

Acting

This viewpoint was some distance away and, as I was unable to approach any closer without losing this very pleasing arrangement, I had to use a long-focus lens in order to isolate this area of the scene.

Technical Details
▼ 6 x 4.5cm SLR camera with a 300mm lens and 81B warm-up filter on Fuji Velvia.

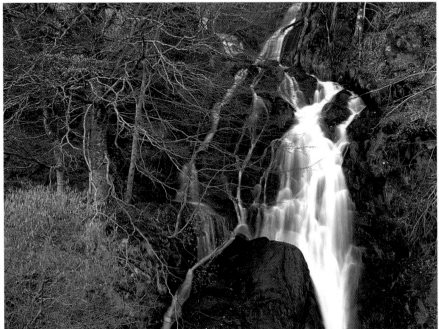

The Valley of Chaudefour near le Mont-Dore in the Auvergne region of France

Technical Details
▼ 6 x 4.5cm SLR camera with a 105–210mm zoom lens and 81A warm-up filter on Fuji Velvia.

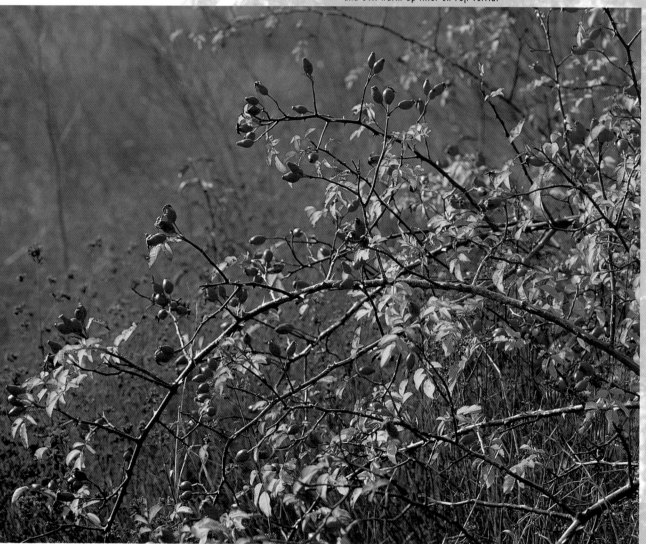

The North Downs near Otford in Kent, UK

This, too, was a winter shot taken on a day with hazy sunlight. I liked the way the soft back-lighting had made the red berries and golden leaves almost seem to leap out from the subdued brown background, creating a bold, colourful effect. I used a long-focus lens to frame a small section of the bush and set an aperture which would give me enough depth of field to record the most important details sharply but leave the background slightly out of focus.

Colour & Design

The conditions for good landscape photography when shooting in colour can be quite demanding. Unlike many other subjects, the landscape can easily have a rather bland and ordinary quality which has much to do with the preponderance of blue sky and green foliage in the countryside. Consequently, objects and details which create a contrast with these dominant colours, like a field of sunflowers or a tree displaying autumnal colours, are often the key to producing a striking image.

Seeing

The mountainsides in this region were carpeted by these fields of golden and white plants and I had been looking for a contrasting feature which would help to create a striking composition. I saw this rather small and insignificant tree as I drove along and decided to investigate.

Thinking

From where I first saw the tree it appeared to be almost in the middle of the field and rather lost but as I approached more closely I realised that with a very close and low viewpoint I might be able to make it appear on the horizon where its impact would be much greater.

Acting

I chose a viewpoint which placed the most attractive area of the plants in the immediate foreground and set the camera quite low, almost to the tops of the plants, and as close as I needed to place the tree on the horizon. I used a wide-angle lens to allow me to include as much of the foreground as possible and a good area of the sky. I framed the image so that the tree was not quite on the intersection of thirds.

Reed beds near Priego in Castile Leon, Spain

I was attracted by the three distinct bands of colour in this image with the contrasting red reeds and blue sky being separated by the silvery tree trunks. I used a long-focus lens to isolate the most striking part of the scene and used a polarising filter to increase the colour saturation, with an 81C warm-up filter to give the reds an added boost.

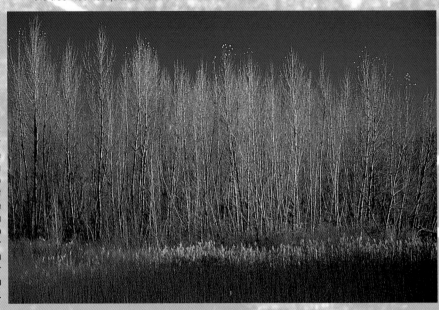

Technical Details
6 x 4.5cm SLR camera with a 55–110mm zoom lens,
81B warm-up and polarising filters on Fuji Velvia.

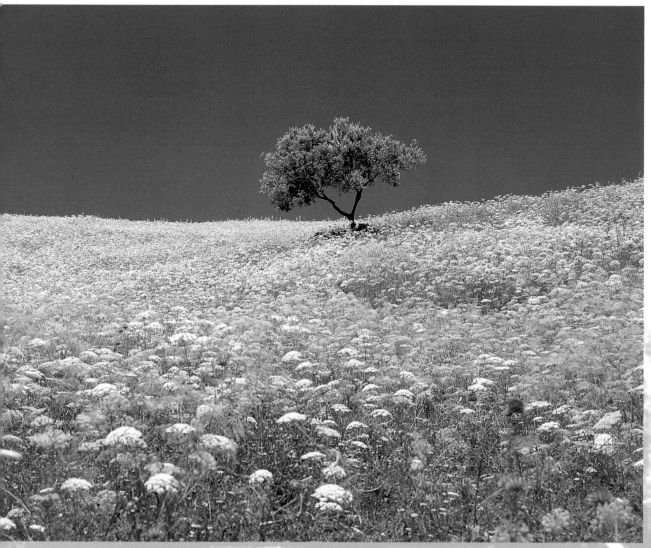

A spring meadow near Velez Malaga in Andalucia, Spain

Here you can see how much less effective the photograph would have been if it had been taken from a higher and more distant viewpoint, with the tree set against the field instead of the sky.

Technical Details
35mm SLR camera with a 75–300mm zoom lens,
polarising and 81C warm-up filters on Fuji Velvia.

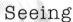

Seeing

In the winter the vines are pruned right back to the stumps which reveals this tracery of wires which is set up to support the vines when they are in leaf. Because the wires are very thin and **reflective** they're not always very visible. But on this occasion, as the sun was going down I could see that, from the right **viewpoint**, there could be a potentially powerful image.

Thinking

I drove around this area for a while before finding this **viewpoint** on a slight rise in the essentially flat landscape. It was **elevated** enough to give me a view of the tops of the wires and for them to reflect the orange sky.

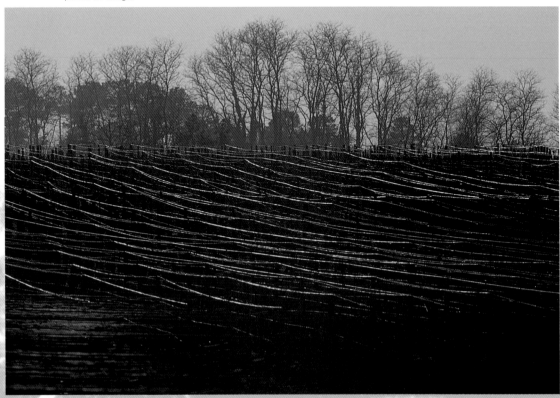

Technical Details
35mm SLR camera with a 150–500mm zoom lens on Fuji Velvia.

The vineyards of Chateau Mouton Rothschild near Pauillac in the Medoc region of France

Acting

I was now quite distant from the area where the effect was strongest. I needed to use the longest setting on my long-focus zoom lens in order to isolate this area and use both the camera's mirror lock and delayed action setting to eliminate the risk of camera shake.

It was the intense greenness which attracted me to this scene. Because I was seeing the sloping olive grove from the opposite side of a small, steep valley I had an almost aerial view of the trees which reduced the image to mysterious patterns of disparate shapes which the monochromatic quality of the image enhanced. I used a long-focus lens to isolate the most effective area of the scene.

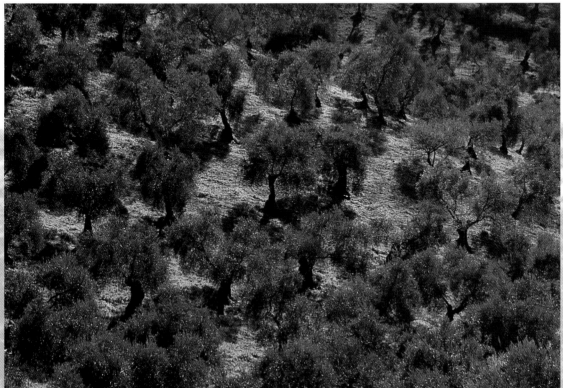

An olive grove near Casares in Andalucia, Spain

Technical Details
35mm SLR camera with a 75–300mm zoom lens, polarising and 81C warm-up filters on Fuji Velvia.

Light & the Image

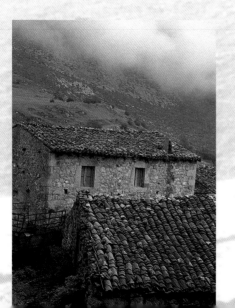

3

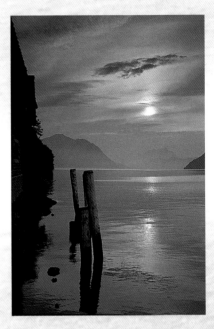

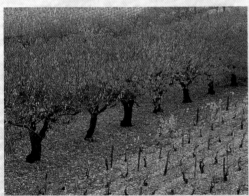

The relationship between light and the landscape is
one which has fascinated countless photographers since the medium was invented and its
effects can be both subtle and dramatic within the space of seconds. This chapter demonstrates
how to be aware of the often fleeting effects which are created and
how to record them successfully.

Shooting in Sunlight

While a bright sunny day is by no means essential for successful landscape photography, it is on these occasions that most keen photographers are tempted to venture forth with their cameras. But strong sunlight can produce unattractive effects if some care is not taken over the choice of viewpoint and the way the image is framed. This can be especially true of very bright summer days when the sky is a deep blue and there are no clouds to soften it or to reflect light into the shadows.

Seeing

It was a beautiful December afternoon as I travelled through this valley and the warm-toned, sharply angled sunlight was enhancing the colour of the rust-red bracken as well as creating well-defined shadows and revealing a rich texture. Above the mountain-top the sky was a clear, deep blue.

Thinking

My first thought was to choose a viewpoint and frame the image so that an area of blue sky was included. In fact I did so, and the result was quite pleasing but I felt that in some ways this had detracted from the powerful effect which the sunlight had created on the bracken.

Acting

I decided to change my viewpoint slightly which enabled me to include the trees at the bottom of the picture and to frame the image more tightly so that the sky was excluded and the emphasis was placed more strongly upon the effects of the sunlight.

The valley of the River Duddon in Cumbria, UK

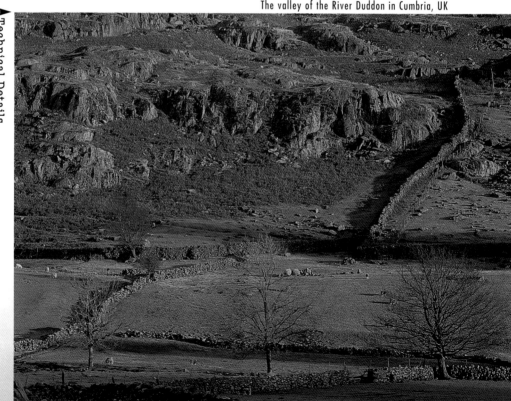

► Technical Details
6 x 4.5cm SLR camera with a 105–210mm zoom lens, 81B warm-up and polarising filters on Fuji Velvia

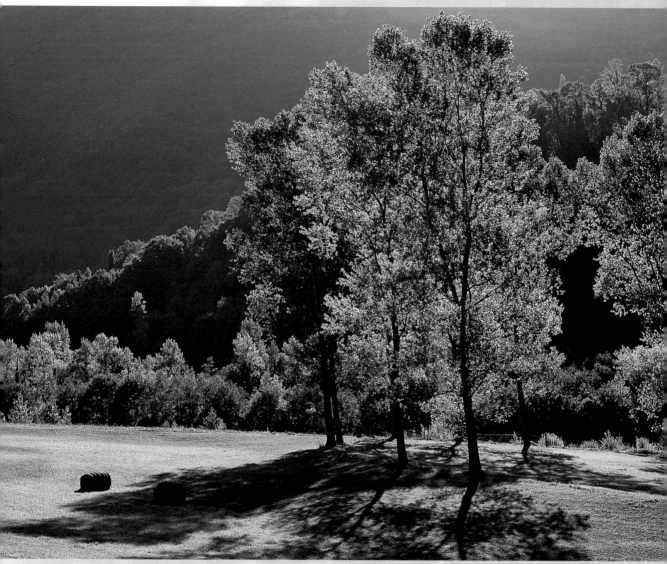

▲ Technical Details
6 x 4.5cm SLR camera with a 105–210mm zoom lens
and 81B warm-up filter on Fuji Velvia.

Near Lourdes in the Hautes Pyrenees region of France

It was late afternoon when I saw this scene in a narrow Pyrenean valley and I was
attracted by the effect which the back-lighting had created as I looked towards this
group of trees. In order to retain the dramatic quality of the lighting I needed to
frame the image so that the mountain-top and pale sky were excluded, allowing the
dark, shaded mountainside to create a bold contrast with the highlighted trees.

Technique

The right level of contrast is very important in colour
photography. Too little and the image will appear flat
and lacking in colour saturation, too much and the
photograph will be harsh and unappealing and the
subtlety of the colours will be lost.

Shooting in Sunlight

Seeing

I was immediately attracted by this beautifully shaped lone tree with a deep blue sky behind it. But from the position where I first saw it, the very strong sunlight was creating a quite harsh quality with half the tree in deep shadow and the other half very brightly lit.

Thinking

I decided to walk around the tree to see if a change in the viewpoint and the corresponding change in the angle of the lighting would improve its effect. As the tree was almost symmetrical, a change in viewpoint had little effect on its shape but the lighting quality improved dramatically.

Acting

I used a low camera angle to ensure the tree trunk was placed against the sky and not the grass, and used a polarising filter to maximise the colour saturation of both the sky and the green leaves.

The Sierra de Cazorla in Andalucia, Spain

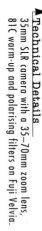

Technical Details
35mm SLR camera with a 35–70mm zoom lens, 81C warm-up and polarising filters on Fuji Velvia.

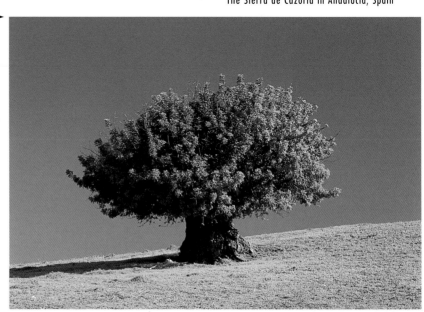

Near Coulon in the Marais Poitevin region of Deux Sèvres, France

Because this was a very hazy day, when the sunlight was soft and created little contrast, I was able to choose a viewpoint and frame the image in such a way that I could include almost equal amounts of shadow and highlighted areas without the image appearing too contrasty.

▲ Technical Details
6 x 4.5cm SLR camera with a 55–110mm zoom lens and 81B warm-up filter on Fuji Velvia.

Technique

It can help you to judge the contrast of a scene by viewing it through half-closed eyes or through the viewfinder of an SLR camera with the lens stopped down.

Rule of Thumb

Strong sunlight can produce too much contrast and create harsh images with little detail in either the shadow or highlight areas. When this happens, you can often create a more pleasing quality by shooting into the light.

Rule of Thumb

Although the subject itself, combined with the angle and quality of light, are primarily responsible for establishing the contrast of an image, a considerable amount of control can be achieved by the choice of viewpoint and the way in which the image is framed.

The Time of Day

The time of day can have a considerable effect on the quality and mood of a photograph. In the middle of the day the sun reaches its highest peak and the shadows are at their smallest. The colour quality of the light at this time is also at its bluest. Earlier and later in the day the light has a much warmer quality and the shadows lengthen. Also, of course, during a day in high summer the angle of the sun in relation to a particular view changes by almost 180 degrees.

Seeing

This dramatic outcrop of red rock overlooking the bay of Porto is a famous Corsican landmark but like many such places it can be hard to photograph in a way which captures something of its astonishing colour and rugged character.

Thinking

Finding a good viewpoint was not very difficult – in fact, I saw this from the roadside on the outskirts of the village and it proved to be one of the most impressive aspects of the site. However, I felt that, lit in the normal way, the rocks would not have the impact I hoped to achieve.

Acting

I planned to return later in the day, towards sundown, to see if at this time the angle of the light would create strong relief as well as accentuating the rich colour of the rock. To my delight both of these things occurred and the sun set at an angle which allowed me to leave it until the very last moment before shooting which has produced this almost unreal colour with very pronounced contours and texture.

Les Calanches near the village of Piana in Corsica

▶ Technical Details
35mm SLR camera with an 80–200mm zoom lens on Fuji Velvia.

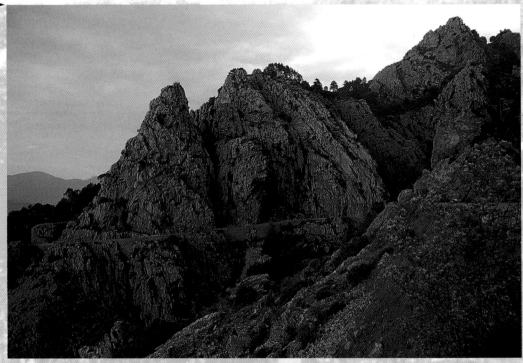

Rule of Thumb

Shadows are the key to judging the quality and direction of the light and therefore also how it affects the image. If you learn to see how and where the shadows fall, how sharp their edges are and how dense, you will soon have a clear understanding of how the lighting affects a scene and if your photograph might be improved by waiting or returning another time.

The River Dordogne seen from the village of Domme in the region of Aquitaine, France

This viewpoint is one of the best from which to photograph the river Dordogne and is very easy to find. In order to produce an image with a more subtle and interesting colour quality, I simply got up very early to shoot the scene just before the sun came up and while there was still some mist lingering in the valley.

Technical Details
▼ 35mm SLR camera with an 80–200mm zoom lens on Fuji Velvia.

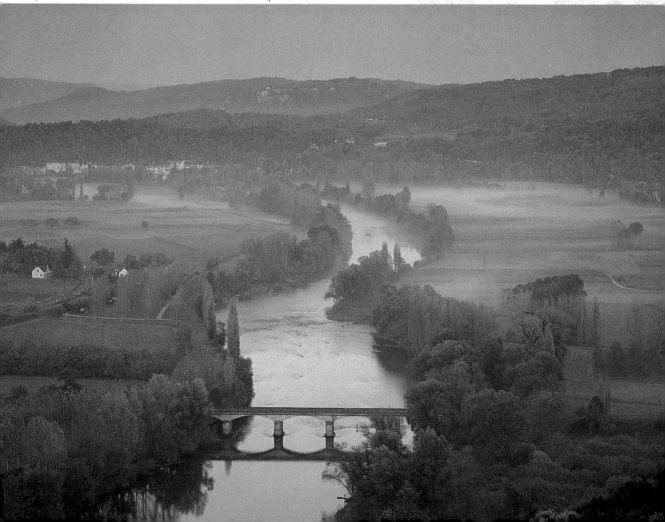

Seeing

I came across this wintry scene in the early afternoon on a day when the sun was strong and the sky quite clear. In open countryside, this lighting would have probably produced an image with only a small amount of shadow and little contrast but here, with the steep contours and bare trees, it created almost too much contrast.

Thinking

I liked the rich texture the lighting had produced and felt that if I could find the right viewpoint I would be able to use the hard lighting to good effect.

Near Aubenas in the Ardèche region of France

▲Technical Details
6 x 4.5cm SLR camera with a 55–110mm zoom lens,
81B warm-up and polarising filters on Fuji Velvia.

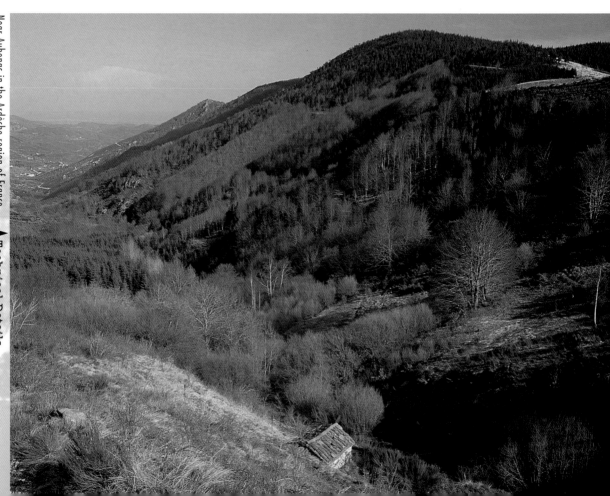

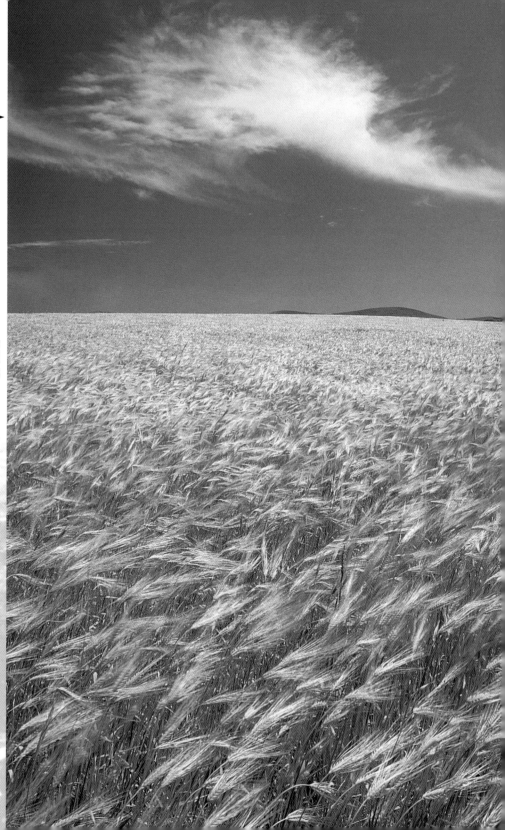

Technical Details ►
35mm SLR camera with a
20–35mm zoom lens,
81C warm-up and polarising
filters on Fuji Velvia.

Acting

I found that from this
viewpoint I was
able to bring a little of the
near slope into the
foreground together with
the small stone hut which
helped to give the image a
sense of **depth and
distance**. By framing
the image quite tightly I
was also able to exclude
some of the deepest area
of shadow and throw
more emphasis on to the
highlighted trees on the
right of the image in a
way which seemed to
create a pleasing balance
overall.

A wheat field near Avila in
Castile Leon, Spain

I saw this beautiful field of
ripe, golden corn as I was
driving along a country road
in the middle of the day. The
overhead sunlight was
creating only very small
shadows and the conditions
for normal landscape shots
were not ideal. But this
lighting had created a very
pleasing, shimmering quality
on the ears of wheat and the
presence of the strong blue
sky and white cloud added
the necessary degree of
contrast and interest.

Shooting on Cloudy Days

A warm, sunny summer's day is the sort of occasion most photographers would choose when planning a day's landscape photography. But a cloudy or overcast day can still create very pleasing effects and even bad weather conditions, such as fog, frost and stormy skies, can give an image an instant eye-catching quality and create a degree of interest and impact which can be lacking in the more bland light of a perfect sunny day.

Seeing

It had been a clear sunny day but as I climbed into the mountains a **dense, low cloud** enveloped the landscape, reducing visibility to only a hundred metres or so. But there were occasional glimpses of trees and rocks which made me feel that, with the right subject, I might well be able to produce an interesting photograph.

Thinking

As I approached a small hamlet, the **bright red** tiled roofs of these two barns almost seemed to light up the road and made an ideal subject to set against the murky background.

Acting

I found a slightly **raised viewpoint** which enabled me to look down on the nearest roof and to fill the foreground with colour. I framed the shot tightly to make the most of the red tiles and also to exclude some distracting details at the sides.

Technical Details
▼ 6 x 4.5cm SLR camera with a 55–110mm zoom lens on Fuji Velvia.

Near Potes in the Picos de Europa, Cantabria, Spain

Taken on a similarly murky day, this barn is much further from the camera than the previous picture and its colour is very muted, but its shape has become very dominant through the mist. This alone would not have interested me but the nicely placed tree beside it made the image work for me and the small window added interest to the shape of the barn.

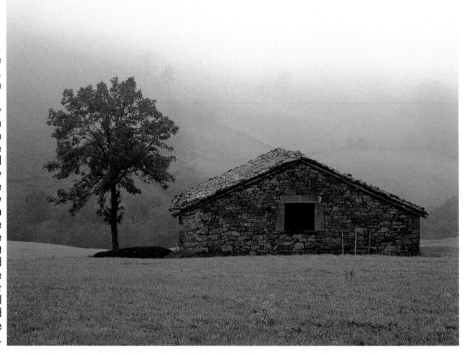

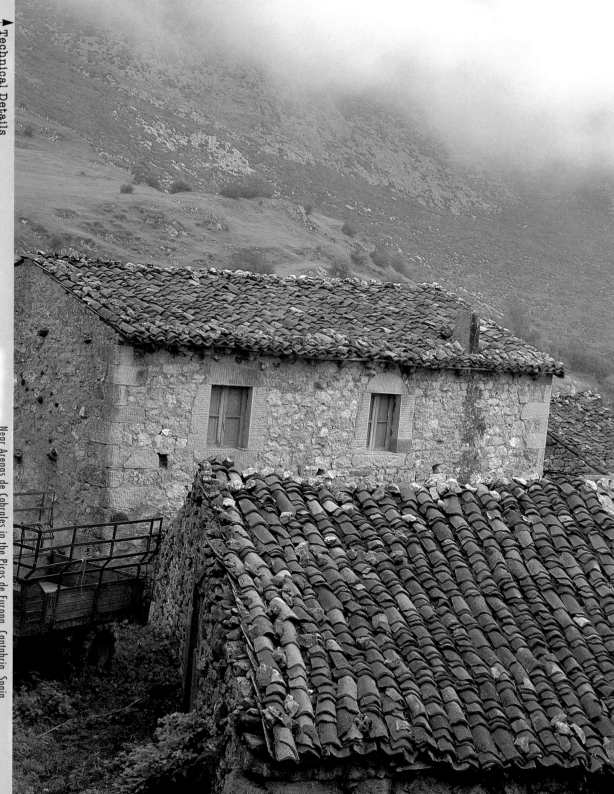

▶ **Technical Details**
6 x 4.5cm SLR camera with a 55–110mm zoom lens on Fuji Velvia.

Near Arenas de Cabrales in the Picos de Europa, Cantabria, Spain

Shooting on Cloudy Days

Seeing

This shot was taken on a late October day when the sky was heavily **overcast** and it was **raining**. The scene was very softly lit but I was attracted by the misty background, the **subtle colour** of the autumn leaves and the water.

Thinking

I realised that the problem would be **insufficient contrast** and that the image could easily be flat and uninteresting and looked for a way in which I could overcome this.

Acting

I found this viewpoint which placed the overhanging branches of a tree very close to the camera. Being **silhouetted**, they added a considerable amount of **contrast** to the image as well as increasing the sense of **depth** and distance and they also helped to create a more interesting **composition**. I used a **small aperture** to ensure both the foreground branches and more distant details were recorded sharply.

The Forest of Compiègne in the Picardy region of France

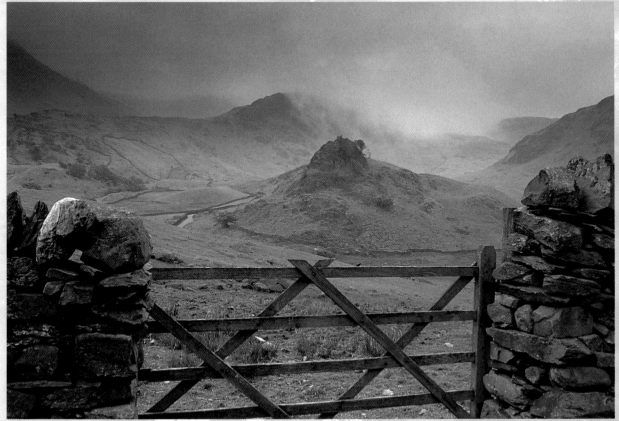

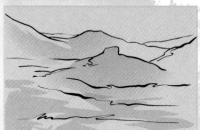 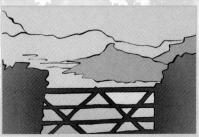

Wrynose Pass in Cumbria, UK

It was a very murky day in winter with very poor visibility as I travelled over this pass and there appeared to be very little chance of an interesting photograph. But this old farm gate and dry-stone wall provided the essential element of foreground contrast and I was able to use a neutral-graduated filter to reduce the sky exposure to reveal some interesting tone and colour.

See how the impact of the image has been increased by the inclusion of dark foreground details.

Technical Details
35mm SLR camera with a 24mm lens, 81B warm-up and neutral-graduated filters on Fuji Velvia.

Technical Details
6 x 4.5cm SLR camera with a 55–110mm zoom lens and 81B warm-up filter on Fuji Velvia.

There are few photographers who can resist the temptation of a spectacular sunset or sunrise, and staying up late and getting up early are two of the best ways of increasing your chances of taking pictures which stand out from the crowd. As well as the more dramatic qualities of sunrises or sunsets, dusk and dawn can create some quite subtle and beautiful effects, even on a cloudy day. But some care is needed if your photographs are to capture the stunning effects you see before you as the brightness range of scenes like these is often beyond the range of colour films unless you take steps to control it.

Seeing

This is a very beautiful beach, about seven miles long, but with very few interesting features along the coastline or shore. For this reason I felt my best chance of a striking photograph would be at sunset, as it had a westerly outlook.

Thinking

I arrived about half an hour before the sun was due to set and walked along the shore looking for a viewpoint where the incoming waves were making a nice shape. I decided to use a wide-angle lens and a viewpoint which allowed the surf to come up almost to the camera.

Acting

I waited until the sun was weakened by its proximity to the horizon, and by passing clouds, and then made a series of exposures over a period which extended until sometime after it had set. The resulting images were extremely varied in both colour and quality – these two pictures were taken within only about ten minutes of each other.

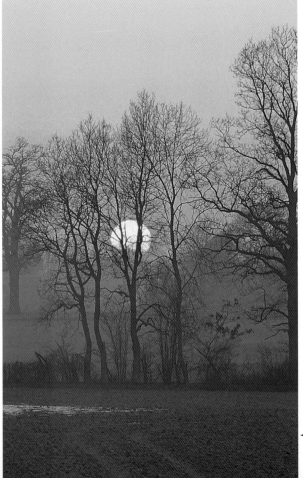

The Darent Valley near Tonbridge in Kent, UK

I'd been looking for a location from which I might be able to shoot a large sun setting close to the horizon and which had something of interest in the foreground. This large flat meadow with a pleasingly shaped group of trees in the distance seemed ideal and the presence of some lingering snow added a further element of interest.

Technical Details
35mm SLR camera with a 150–500mm zoom lens on Fuji Velvia.

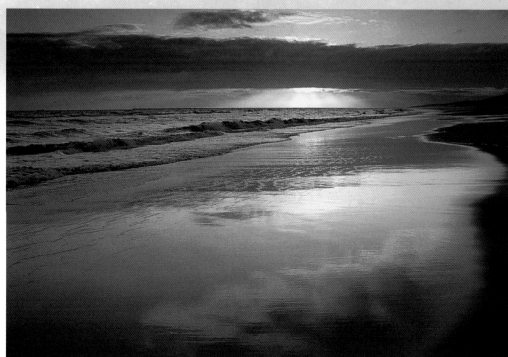

The beach
near
Mazagon
in the
province of
Huelva in
Andalucia,
Spain

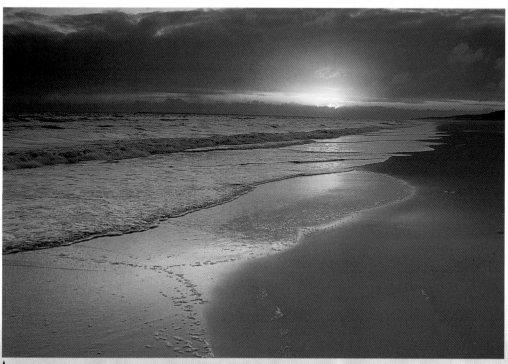

▲ Technical Details
35mm SLR camera with a 20–35mm zoom lens on Fuji Velvia.

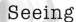

Seeing

I woke in my hotel on this morning to find that the view from my window was completely obliterated by a dense fog. But as I travelled higher on to the moor I could see that the sun was only quite thinly veiled in places and thought that if it became just a little bit stronger there might well be the possibility of a good picture.

Thinking

I found this small group of trees and decided I would wait to see if the sun might break through, setting up my camera, choosing my viewpoint and framing the image in readiness.

Acting

My efforts were rewarded when this sudden clearing in the fog allowed the sun to filter through casting this delicious golden light over the scene. I used a neutral-graduated filter to help even the balance between the very bright sky and the darker foreground.

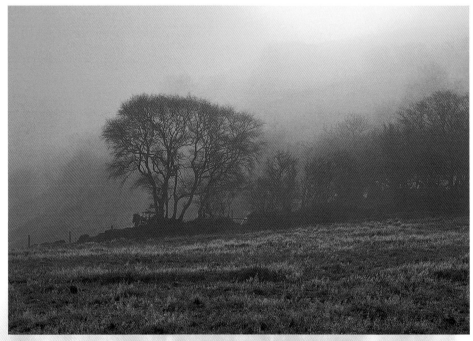

Exmoor near Combe Martin in North Devon, UK

Victoria Falls, Zimbabwe

I wanted to go home with an interesting photograph of this famous site, and in normal daylight hours, although it looked mightily impressive, I felt that it needed another element to help capture its remarkable drama on film. Lighting quality is often the factor which lifts an image from the ordinary so I decided to arrive at this spot in time for sunrise. I had to shoot the picture very quickly after the sun appeared over the falls as it gained strength very rapidly and soon became too bright to record on film. I used a neutral-graduated filter to help weaken it further.

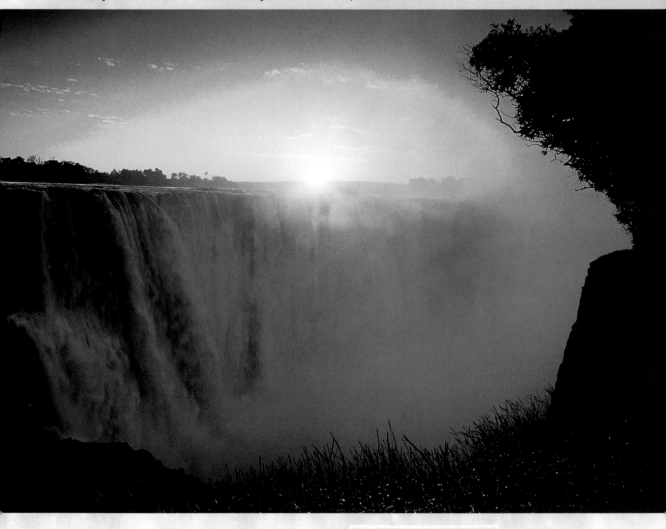

▲ Technical Details
35mm SLR camera with a 20–35mm zoom lens on Fuji Velvia.

◄ Technical Details
35mm SLR camera with a 35–70mm zoom lens and neutral-graduated filter on Fuji Velvia.

Rule of Thumb

It helps to know precisely where to go when planning to shoot a sunrise or sunset. Getting up at 4 am and then driving round looking for something to photograph is a recipe for frustration and disappointment. When travelling around I like to keep a look out for possible locations with interesting foregrounds, using a compass to establish where the colourful sky is likely to be.

Light & Texture

The medium of photography is especially effective at conveying an impression of texture and this can be a powerful element in landscape photography, both in distant views and with more close-up images. The effect of texture is largely dependent upon the direction and quality of the light in relation to the nature of the surface it illuminates. In a distant landscape, acutely angled sunlight, such as that of late afternoon, might be necessary to reveal this quality but with a closer image, such as a detail of rocks or trees, a softer, more frontal light is likely to be more effective.

Seeing

It was a wintry afternoon with a quite weak sun when I saw this outcrop of rock. I was taken by its shape but also by the wonderfully textural quality which the angled sunlight had created.

Thinking

The sun was at such an acute angle that had it been a clearer day, and the sunlight any stronger, the image would have simply been too contrasty and the textural quality greatly diminished.

Acting

I chose a viewpoint which presented the most pleasing aspect of the rock and also placed the bright part of the cloudy sky in the most effective juxtaposition with it. I decided not to use a warm-up filter as I felt the resulting blue cast might contribute to the atmosphere of the photograph.

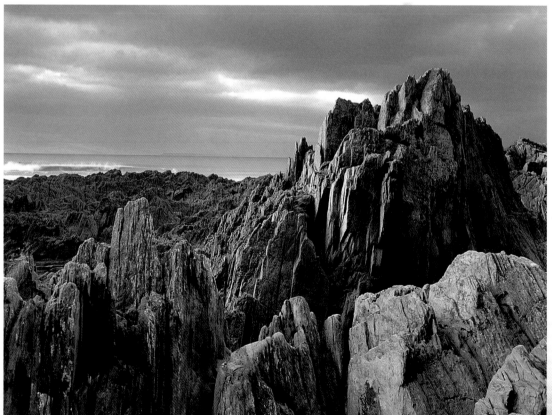

Barricane Beach near Woolacombe in North Devon, UK

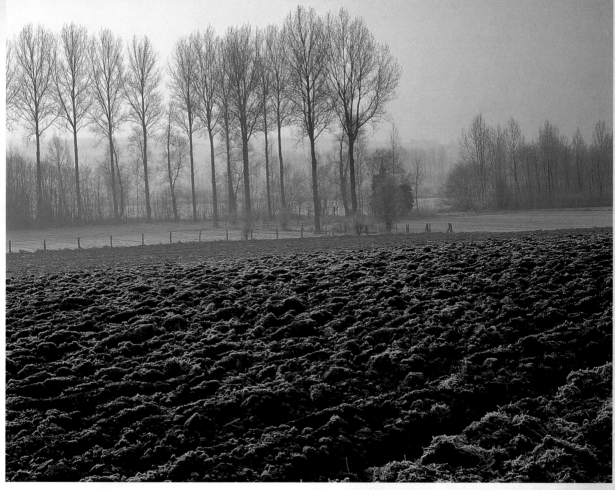

The Ternoise Valley near Montreuil in the Pas-de-Calais region of France

I saw this scene very early on a winter's morning when a hoar frost had carpeted the landscape. The combination of the newly ploughed field with its deep furrows and the highlights created by the frost and the low-angled sunlight skimming across the field has produced an image with a very striking impression of texture.

Rule of Thumb

Creating a strong impression of texture needs the image to be critically sharp and it's best to use a slow, fine-grained film, select a small aperture to ensure adequate depth of field and use a tripod to eliminate the risk of camera shake.

Technical Details
6 x 4.5cm SLR camera with a 55–110mm zoom lens and neutral-graduated filter on Fuji Velvia.

Technical Details
6 x 4.5cm SLR camera with a 55–110mm zoom lens on Fuji Velvia.

Light & Texture

Technique

When using a long-focus lens to isolate a small area of a distant view it's advisable to mount your camera on a **tripod** and use a **cable release** as the effect of camera shake will be magnified. When using an SLR camera, one with a **mirror lock** can be a big advantage as it will eliminate the risk of vibration which is caused when the mirror flips up at the time the exposure is made.

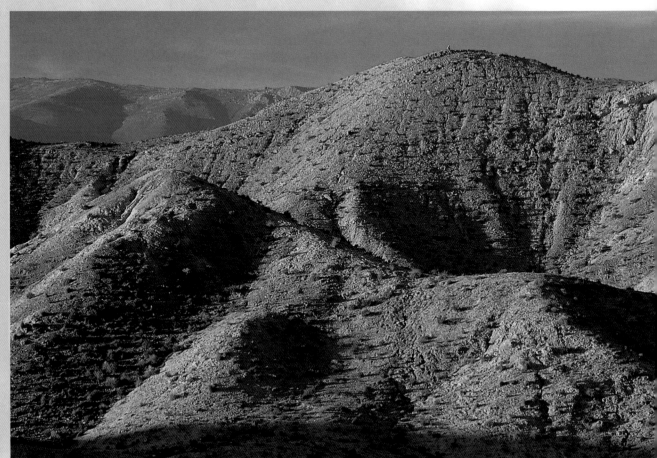

Near Tabernas in the province of Almeria in Andalucia, Spain

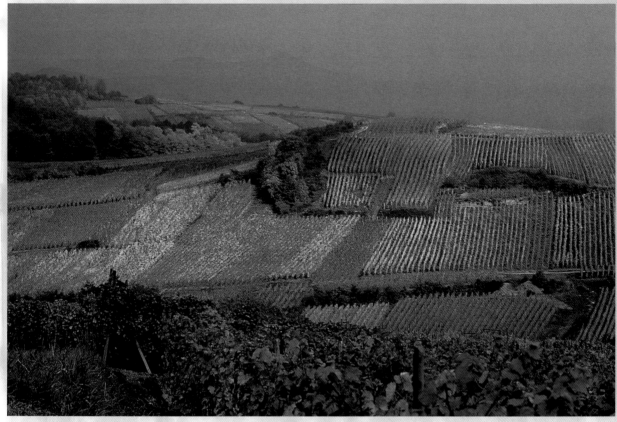

Vineyards near Colmar in the Alsace region of France

The effect of the low-angled evening sunlight on these autumn vineyards created a very strong impression of texture which was enhanced by the rich, warm monochromatic quality of the image. I used a long-focus lens to isolate the most striking section of the landscape.

Seeing

This is a very bleak and barren landscape, where many of the Spaghetti Westerns were made. It is almost treeless and has few features which can be introduced to add colour or other compositional interest to the image.

▲ Technical Details
35mm SLR camera with a 75–300mm zoom lens on Fuji Velvia.

◄ Technical Details
35mm SLR camera with a 75–300mm zoom lens, 81B warm-up and polarising filters on Fuji Velvia.

Thinking

I'd seen this viewpoint as I'd driven along a quiet country road earlier in the day and felt that at a different time, when the sun was at a lower angle, it might create a much more interesting image.

Acting

I was very pleased to find on returning, towards the end of the afternoon, that the sun was now creating quite striking contours and textures and its much warmer colour quality had added a richness to the terrain which now produced a bold contrast against the blue sky. I used a polarising filter to accentuate this and a warm-up filter to enhance the warm quality of the soil.

Light & Colour

The colour quality of daylight varies considerably according to the position of the sun in the sky and factors like cloud and blue sky. In the middle of a summer's day, when there is a deep blue sky, the light can be much bluer than the film is balanced for and also when shooting subjects in open shade and on a cloudy, overcast day. This will create a blue cast on transparency film. Conversely, early morning and late afternoon sunlight can be much yellower than the film is balanced for and this can create a warm colour cast.

Rule of Thumb

When considering whether or not to use a warm-up filter it's worth bearing in mind that, for normal sunlit landscapes, a blue colour cast is invariably less attractive than when the image is a little too warm.

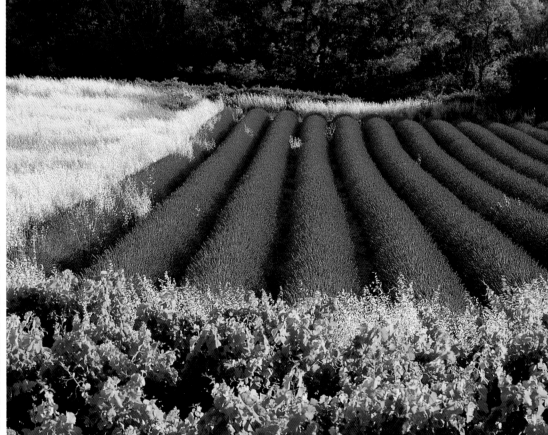

A lavender field near Gordes in the Luberon region of Provence, France

I chose a viewpoint which allowed me to shoot along the rows of lavender and into the light, which helped to create the rich colour and texture of this image, and I framed the shot to include some of the contrasting foreground details.

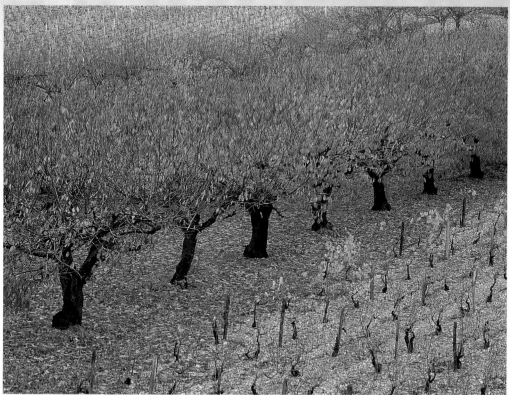

Near the village of Irancy in the Burgundy region of France

See how including more of the scene in the image and making the diagonal line less dominant would have lessened its impact.

Seeing

It was a cloudy, overcast day in November when I chanced upon this scene. I was immediately struck by the vivid colour of the leaves on the cherry trees, which was enhanced by the soft lighting and by the orderly way in which they were planted which created a strong pattern.

Thinking

I thought that my image needed a stronger sense of shape and design, so I looked for a more distant, raised viewpoint which also gave me a side view of the trees and allowed me to include some of the adjoining vineyard in the foreground.

Acting

I used a long-focus lens to exclude all but the most important details in the scene and framed the shot so that the line of trees created a diagonal in the frame. I used a polarising filter to increase the colour saturation of the foliage and a warm-up filter to make the red leaves look even stronger.

Technical Details

6 x 4.5cm SLR camera with a 105–210mm zoom lens, polarising and 81B warm-up filters on Fuji Velvia.

Technical Details

6 x 4.5cm SLR camera with a 55–110mm zoom lens, 81B warm-up and polarising filters on Fuji Velvia.

Light & Colour

Seeing

I had been skirting the lake shore looking for the possibility of an interesting photograph when I discovered a small jetty near these two weathered mooring posts which I thought could provide effective foreground interest.

Thinking

It was late afternoon on a hazy day and I noticed that the light had a rather pleasing bluish quality which created an atmospheric effect and, together with the curious cloud formation, I felt that this might be enough to provide the extra interest I felt the image needed.

Acting

I chose a viewpoint which allowed me to place the two poles at more-or-less the intersection of thirds and well-balanced with the lightest part of the sky and then framed the shot to include part of the foreshore. I used a neutral-graduated filter to balance the brightness of the sky with its reflection in the water.

This shows how the impact of the photograph would have been lessened had the image not been cropped so tightly.

Technical Details

6 x 4.5cm SLR camera with a 55–110mm zoom lens, 81B warm-up and polarising filters on Fuji Velvia.

The valley of the River Tajo near Cuenca in Castile La Mancha, Spain

I was driving through this small valley in late afternoon on an autumn day and as the road climbed out of it I saw this scene where the back-lighting had created an almost spot-lit effect on the small tree plantation. I also liked the fact that the tips of the trees had remained green. I framed the shot tightly to restrict the image to just two colours and to exclude the sky. I used polarising and warm-up filters to increase the colour saturation.

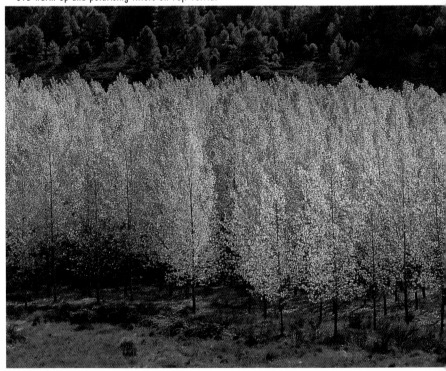

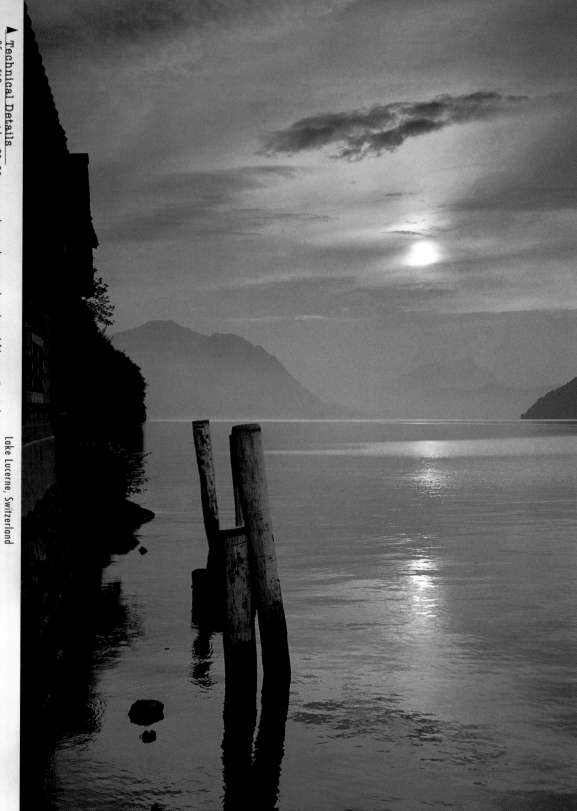

▲ Technical Details
35mm SLR camera with a 20–35mm zoom lens and a neutral-graduated filter on Fuji Velvia.

Lake Lucerne, Switzerland

Light & Mood

Mood is an elusive element in a photograph – it's something which can often be present in a situation but it is very difficult to convey on film. Light, colour and mood are closely linked – the blues and greens which dominate the landscape tend to have a restful or peaceful quality, while warmer colours create a more vigorous and assertive mood and darker, more subdued hues can produce a sombre or even sinister atmosphere.

Seeing

I had been travelling through this valley on a midwinter's afternoon when the sky had been filled with dense cloud. But as I neared this location some gaps had developed, allowing small pools of sunlight to play on the landscape, like a travelling spot-light.

Thinking

I wanted to find a viewpoint which would allow me to include some foreground interest and this grey dry-stone wall seemed ideal as it created a bold contrast with the red bracken beyond.

Acting

I set up my camera at this spot and framed the shot so that the curving wall filled the foreground and then waited for the sunlight to reach the area I was aimed at. The sun was very low and, when fully out, cast my own shadow on to the wall, so I had to wait until the foreground was partially in shadow before making my exposures. This has also helped to increase the impact and mood of the shot.

Farndale in the North York Moors, UK

Technical Details
6 x 4.5cm SLR camera with a 55–110mm zoom lens, 81B warm-up and polarising filters on Fuji Velvia.

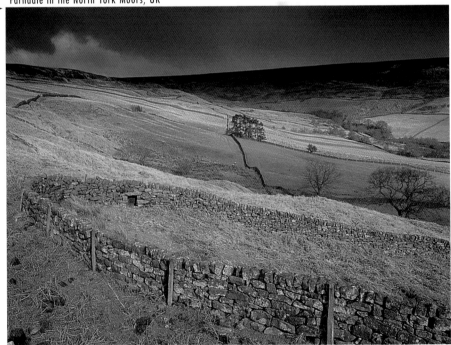

Dovedale in Derbyshire, UK

The sunlight on this beautiful spring morning created a sparkling quality as it filtered through the trees and, combined with the intense green, monochromatic nature of the scene, produced an image with an upbeat but peaceful atmosphere. I used a polarising filter to increase the colour saturation and the strength of the reflections and a warm-up filter to make the greens even richer.

<u>Technical Details</u>
▼ 6 x 4.5cm SLR camera with a 55–110mm zoom lens, 81C warm-up and polarising filters on Fuji Velvia.

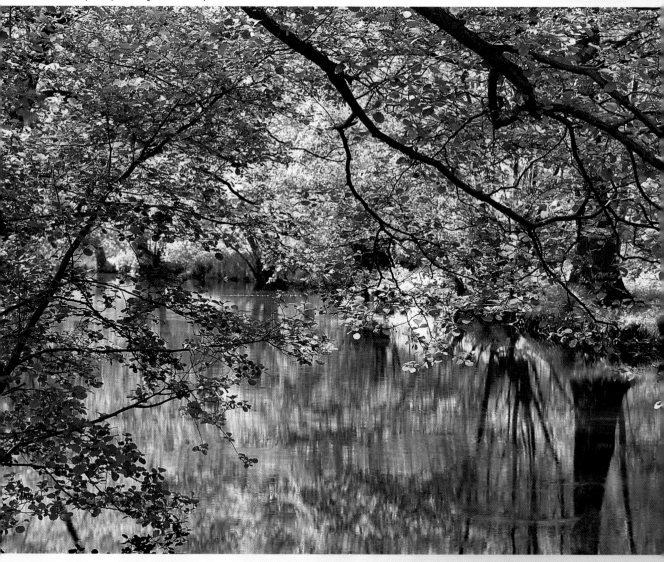

Light & Mood

Seeing

It was a slightly misty morning as I travelled through this forest and I had been looking for an interesting arrangement of trees when this very sudden shaft of sunlight appeared.

Thinking

I had only a very short time to set up, frame and shoot the picture as the sun very quickly cleared the mist and soon the shafts of light were no longer visible.

Acting

I had no time to look for different viewpoints and my main concern was to frame the image in a way that created a sense of order in a fairly complex scene while at the same time incorporating the most interesting and dominant shafts of light. I only had time to make a small bracket of exposures and the best frame was one which was slightly darker than normal.

Near Macôn in the Burgundy region of France

Technical Details

6 x 4.5cm SLR camera with a 55–110mm zoom lens and 81B warm-up filter on Fuji Velvia.

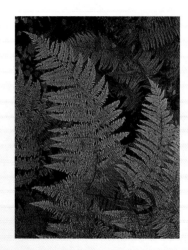

4

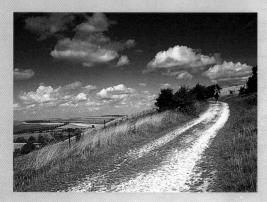

The choice of equipment for landscape photography is an entirely personal one as even the simplest camera is capable, in the right hands, of producing striking images. In this chapter the advantages and benefits of different systems are described to help determine the best choice for your particular interests.

Choosing a Camera

The choice of camera, type and format for landscape photography depends very largely upon your approach to the subject and upon the way in which you wish to use the images you produce. For fine art and pictorial landscape photographs, for instance, a small format camera could be ideal. However, if you wish to take photographs for book or magazine reproduction the greater image quality created by the use of larger formats could make this type of camera a better choice.

Formats

Image size is the most basic consideration. The image area of a 35mm camera is approximately 24 x 36mm but with roll film it can be from 45 x 60mm up to 90 x 60mm according to camera choice. The degree of enlargement needed to provide, say, an A4 reproduction is considerably less for a roll film format than for 35mm and gives a potentially higher image quality.

For most photographers the choice is between 35mm and 120 roll film cameras. Advanced Photo System (APS) cameras offer a format slightly smaller than 35mm. For images larger than 6 x 9cm it is necessary to use a view camera using sheet film of 5 x 4in or 10 x 8in format.

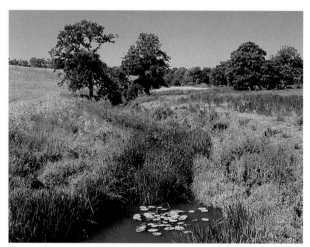

The Darent Valley near Penshurst in Kent, UK

For subjects like this, taken in good lighting conditions, and where a standard lens or mid-range zoom is adequate, an inexpensive compact or viewfinder camera would be quite suitable, especially when colour negative film is used and prints up to 10 x 7in are sufficient.

Pros & Cons

APS cameras have a more limited choice of film types and accessories and are designed primarily for the use of colour print film. 35mm Single Lens Reflex (SLR) cameras are provided with the widest range of film types and accessories and provide the best compromise between image quality, size, weight and cost of equipment.

Both accessories and film costs are significantly more expensive with roll film cameras and the range of lenses and accessories is more limited than with 35mm equipment. Facilities such as autofocus and motor drive are available on very few roll film cameras while they are also generally heavier and bulkier than on 35mm cameras. View cameras provide extensive perspective and depth-of-field control and are especially useful for high-quality landscape photography but are cumbersome and not very user friendly.

Camera Types

There are two basic choices between both roll film and 35mm cameras – the Viewfinder or Rangefinder Camera and the Single Lens Reflex (SLR) camera.

Near Condom in the Gascony region of France

This photograph was taken in the afternoon of a hazy summer's day and I was attracted by the pleasing mixture of light and shade together with the fact that the strong highlight on the track was balanced by the small patch of sunlit field visible through the trees towards the right of the frame. I used a long-focus lens to frame a small section of the scene.

Technical Details
35mm SLR camera with a 75–300mm zoom lens, 81C warm-up and polarising filters on Fuji Velvia.

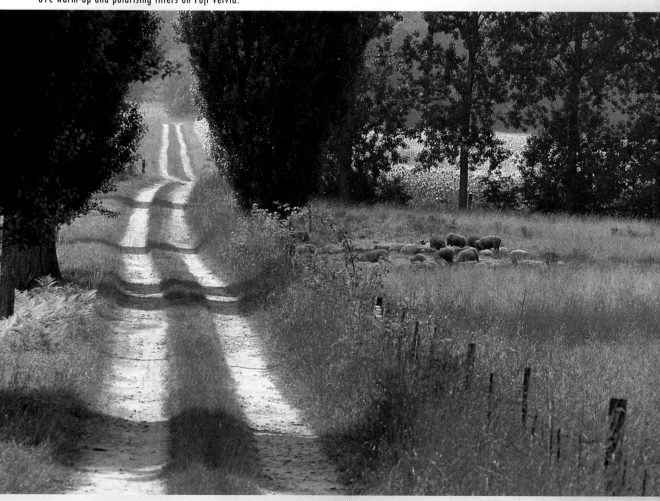

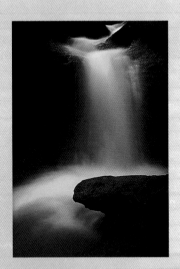

Cameras & Equipment

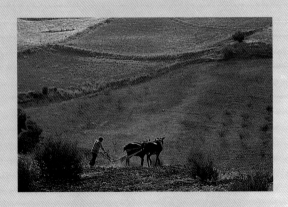

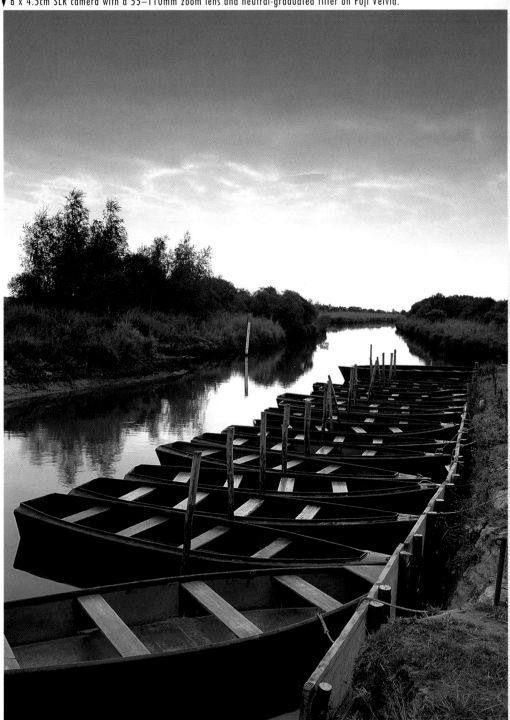

La Grande Briere in
the Western Loire,
France

The viewing system of
an SLR camera makes
the use of polarising
and graduated filters
much easier as the
effects can be seen
and adjusted by
looking through the
lens, as in this image
of moored boats.

Choosing a Camera

Pros & Cons

The SLR camera allows you to view the actual image which is being recorded on the film while the viewfinder camera uses a separate optical system. The effect of focusing can be seen on the screen of an SLR camera but the whole image appears in focus when seen through a viewfinder camera. Generally, facilities like autofocus and exposure control are more accurate and convenient with SLR cameras and you can see the effect of filters and attachments. SLR cameras have a much wider range of accessories and lenses available to them and are more suited to subjects which need very long-focus lenses and for close-ups. However, viewfinder cameras tend to be lighter and quieter than SLR cameras.

This illustration shows a 6 x 17cm roll film panoramic camera.

Specialist Cameras

While it's possible to produce panoramic format photographs with some ordinary 35mm and roll film cameras, dedicated 6 x 12cm, 6 x 17cm and 6 x 24cm cameras are the professional landscape photographer's choice. These are essentially viewfinder cameras taking 120 roll film with a greatly elongated film chamber. Some have fixed wide-angle lenses while others have interchangeable lenses. An alternative to using a dedicated panoramic camera is to use a 6 x 12cm roll film back with a 5 x 4in view camera.

In addition to conventional panoramic cameras there are also swing-lens cameras, such as the Widelux, giving a panoramic image over a wide angle of view. These can be bought in both 35mm and 120 film formats and have a moving lens mount which progressively exposes the film. This gives a more limited range of shutter speeds and also causes horizontal lines to curve if the camera is not held completely level.

6 x 7cm SLR camera with a 200mm lens and 81B warm-up filter on Fuji Velvia.

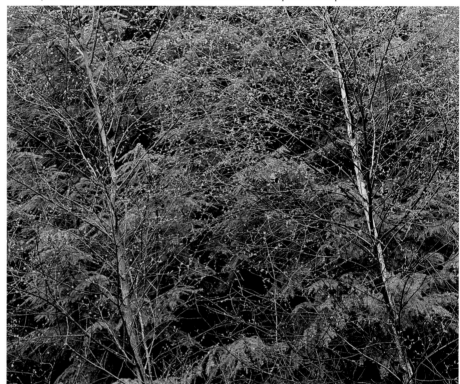

In the Brecon Beacons, Wales, UK

For a very finely detailed image like this, a medium or large format camera can offer significant advantages, especially if large exhibition prints are required.

Fishpond Woods near Sevenoaks in Kent, UK

I felt this subject suited the elongated panoramic format of 6 x 12cm rather well. I used a polarising filter to increase the strength of the reflections and an 81B warm-up filter to accentuate the autumn colours.

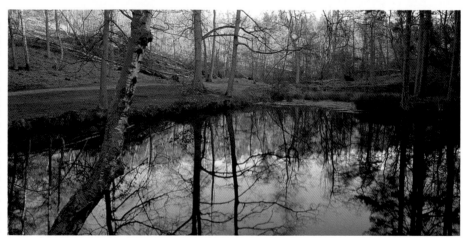

5 x 4in view camera with a 6 x 12cm roll film back, a 90mm wide-angle lens, polarising and 81B warm-up filters on Fuji Velvia.

A standard lens is one which creates a field of view of about 45% degrees, approximating that of normal vision, and has a focal length equivalent to the diagonal measurement of the film format i.e. 50mm with a 35mm camera and 80mm with a 6 x 6cm camera.

Lenses with a shorter focal length create a wider field of view and those with a longer focal length produce a narrower field of view.

Zoom lenses provide a wide range of focal lengths within a single optic, taking up less space and offering more convenience than having several fixed-focal-length lenses.

Pros & Cons

Many inexpensive zooms have a maximum aperture of f5.6 or smaller. This can be quite restricting when fast shutter speeds are needed in low-light levels and a fixed-focal-length lens with a wider maximum aperture of f2.8 or f4 can sometimes be a better choice.

Zoom lenses are available for most 35mm SLR cameras over a wide range of focal lengths but it's important to appreciate that the image quality will drop with lenses which are designed to cover more than about a three to one ratio, i.e. 28-85mm or 70-210mm.

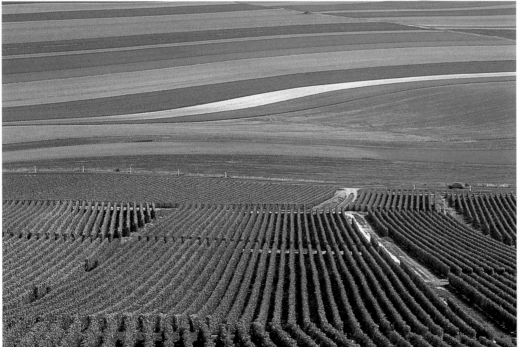

Mont Aimee near Bergeres-les-Vertus in the Champagne region of France

A long-focus lens enables you to isolate a small area of a scene from a distant viewpoint and is invaluable for emphasising elements like pattern and texture in a landscape image.

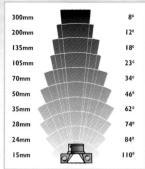

Hawk's Nest Bay in St John, US Virgin Island

I used a wide-angle lens to enable me to use the tree in the close foreground as a frame for the distant scene, which has helped to create a sense of depth and distance in the image.

300mm	8°
200mm	12°
135mm	18°
105mm	23°
70mm	34°
50mm	46°
35mm	62°
28mm	74°
24mm	84°
15mm	110°

This illustration shows the comparative fields of view given with lenses of varying focal lengths when used with a 35mm camera.

Special Lenses

A perspective-control or shift lens can sometimes be useful for landscape photography, especially if buildings are occasionally included. These allow the lens to be physically moved from its axis to enable the image to be moved higher or lower in the frame without the need to tilt the camera, thereby avoiding converging verticals. In this way, the camera's field of view can be lowered to include foreground details, for example, or raised to include more of the sky without the accompanying distortion.

A macro lens is very useful when photographing close-up images of natural forms, making it possible to obtain up to life-sized images without the need for extension tubes or close-up attachments.

Extenders can allow you to increase the focal length of an existing lens – a x1.4 extender will turn a 200mm lens into a 280mm and a x2 extender will make it 400mm. There will be some loss of sharpness with all but the most expensive optics and a reduction in maximum aperture of one and two stops respectively.

Technical Details
35mm SLR camera with a 20–35mm zoom lens, 81C warm-up and polarising filters on Fuji Velvia.

Technical Details
35mm SLR camera with a 75–300mm zoom lens, 81B warm-up and polarising filters on Fuji Velvia.

Camera Accessories

There are a wide range of accessories which can be used
to control the image and increase the camera's capability.
Extension tubes, bellows units and dioptre lenses will all allow the lens to be focused
at a closer distance than it's designed for and this can be useful for obvious close-up
subjects like trees and rocks.

A range of filters is essential for both colour and black and white photography, and a square filter system, such as Cokin or HiTech, is by far the most convenient and practical option. These systems use a universal filter holder which is slipped on to a simple adapter ring available in all lens-thread diameters. In this way the same filter holder can be fitted to all of your lenses.

The most basic filter kit should include a set of warm-up filters, a graduated filter and a polarising filter. For those shooting black and white a few contrast filters, such as yellow or red are a useful addition. Polarising filters are available in either linear or circular form. The former can interfere with some auto-focusing and exposure systems – your camera's instruction book should tell you, but if in doubt use a circular polarising filter.

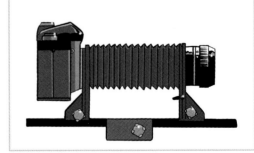

The illustration shows a bellows unit

In Fishpond Woods near Sevenoaks in Kent, UK

I used a long-focus zoom lens in conjunction with an extension
tube to enable me to focus closely enough to fill the frame
with this section of a bracken leaf.

Technical Details
6 x 4.5cm SLR camera with a 105–210mm zoom
lens and an extension tube.

Technical Details

▼ 6 x 4.5cm SLR camera with a 105–210mm zoom lens, 81B warm-up and polarising filters on Fuji Velvia.

Perhaps one of the most important accessories is a **tripod** as it can greatly improve image sharpness, allowing you to shoot pictures in low light levels where hand-held shutter speeds are not possible and to use **small apertures** for greater depth of field. It's best to buy the most substantial one you feel able to carry comfortably as a very lightweight tripod can be of very limited usefulness. A shake-free means of firing the camera, such as a **cable release** or a remote trigger, is advisable when using a tripod-mounted camera.

Although **flash** is of limited value in landscape photography it can be useful to reduce contrast when shooting close-up subjects and to illuminate foreground details. Many cameras now have a built-in flash but these are usually of restricted power and a **separate flash gun** can be a very useful accessory. It will be more powerful than one built-in and it can be used off-camera or fitted with a **diffuser** if required. It's best to buy the most powerful which your budget will allow.

A forest in the Vercors near Die in the Drôme region of France

Although this scene looks quite brightly lit, it was a very overcast day and the level of illumination in the forest was so low that, when a small aperture and a polarising filter were used, an exposure of several seconds was needed, which would have been impossible without a tripod.

The aperture is the device which controls the brightness of the image falling upon the film and is indicated by f stop numbers: f 2, f2.8, f4, f5.6, f8, f11, f16, f 22 and f32. Each step down, from f2.8 to f4, for example, reduces the amount of light reaching the film by 50% and each step up, from f8 to f5.6, for instance, doubles the brightness of the image.

The shutter speed settings control the length of times for which the image is allowed to play on the film and, in conjunction with the aperture, control the exposure and quality of the image. These are provided either in one-stop increments, such as 1/60 second to 1/125 second; half-stop increments, from 1/60 second to 1/100 second; or one-third of a stop increments, from 1/60 second to 1/80 second, for example.

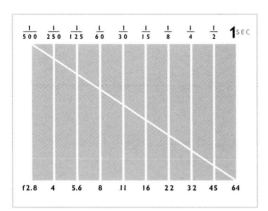

This illustration shows how as the aperture is made smaller and the shutter speed made slower the same amount of exposure is given.

Technique

Choice of aperture also influences the depth of field, which is the distance in front and beyond the point at which the lens is focused. At wide apertures, like f2.8, the depth of field is quite limited, making closer and more distant details appear distinctly out of focus.

The effect becomes more pronounced as the focal length of the lens increases and as the focusing distance decreases. So with, say, a 200mm lens focused at two metres and an aperture of f2.8 the range of sharp focus will extend only a very short distance in front and behind.

The depth of field increases when a smaller aperture is used and when using a short focal length, or wide-angle lens. In this way a 24mm lens focused at, say, 50 metres at an aperture of f22 would provide a wide range of sharp focus extending from quite close to the camera to infinity.

A camera with a depth-of-field preview button will allow you to judge the depth of field in the viewfinder. An indication of the depth of field at different apertures is marked on the focusing mount of most lenses.

Technical Details ▶
35mm SLR camera with a 35mm lens and an 81B warm-up filter on Fuji Velvia.

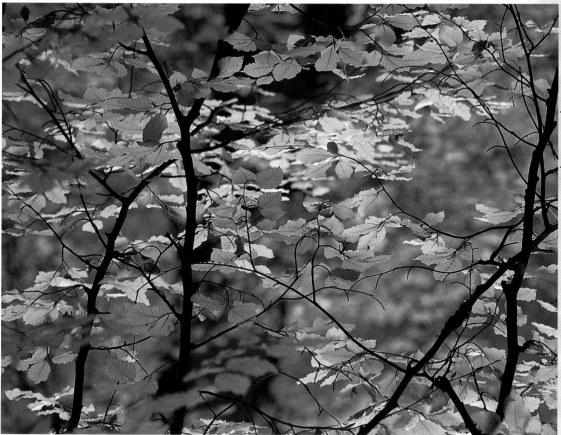

Technical Details
6 x 4.5cm SLR camera with a 105–210mm zoom
lens and an 81A warm-up filter on Fuji Velvia.

Fishpond Woods near Sevenoaks in Kent, UK

I used a long-focus lens and selected a wide
aperture so that only the closest leaves would
be sharp and the more distant details recorded
as a soft, out-of-focus blur.

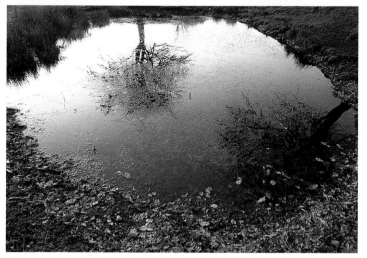

Knole Park near Sevenoaks in Kent, UK

I needed to use a small aperture of f22 to provide enough depth of
field to ensure that both the details at the edge of the pond and the
reflection of the distant trees were equally sharp.

Technical Details
35mm SLR camera with a 35–70mm zoom lens
and a polarising filter on Kodachrome 25.

The choice of **shutter speed** determines the degree of **sharpness** with which a moving subject will be recorded. With a fast-moving subject, like a white-water river, a shutter speed of 1/1000 second or less will be needed to obtain a sharp image of the droplets.

Technique

Trying to achieve a sharp image of a moving subject is not always the best way of photographing it. In some circumstances a very **slow shutter speed** can be used to create striking effects. A classic example is a waterfall. A **tripod** must be used to ensure the static elements of the image are recorded sharply and then a slow shutter speed of, say, one second or more is selected to create a fluid, smoke-like effect.

Rule of Thumb

The choice of shutter speed can also affect the image sharpness of a static subject when the camera is hand held as even slight camera shake can easily cause the image to be blurred. The effect is more pronounced with long-focus lenses and when shooting close-ups. The safest minimum shutter speed should be considered as a reciprocal of the focal length of the lens being used – 1/200 second with a 200mm lens, for instance.

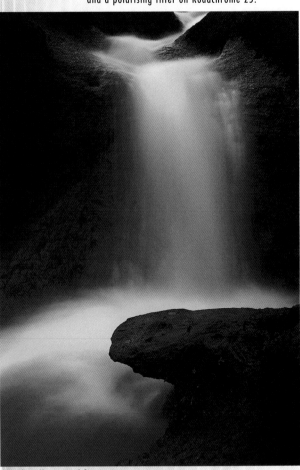

Death Valley in California, USA

I used a long exposure of around five seconds to record this waterfall as a soft, smoke-like blur. The light was quite bright so I used a polarising filter and a small aperture of f22 to reduce the image brightness.

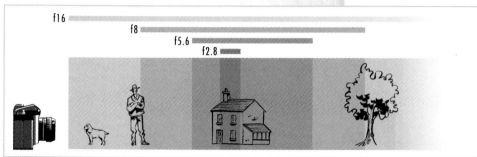

This illustration shows how the band of sharp focus widens as the aperture is reduced for a lens of a given focal length.

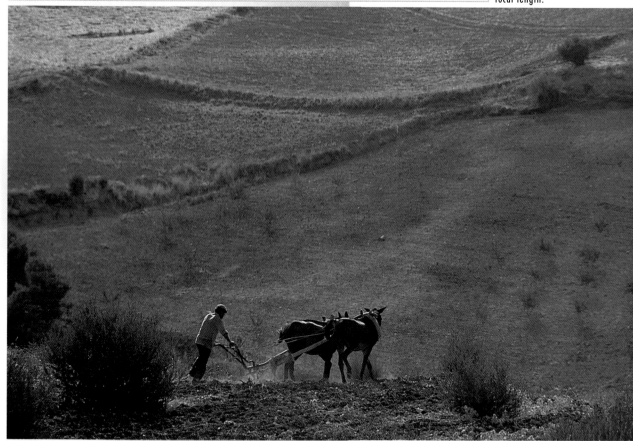

The Puerto de Tiscar near Quesada in Andalucia, Spain

I needed to use a relatively fast shutter speed of 1/125 second to ensure that this man and his horse were not blurred as they moved across the field. Because I was using a long-focus lens, and needed to use a smallish aperture to ensure adequate depth of field, I opted to use a faster film.

▲ Technical Details

35mm SLR camera with a 75–300mm zoom lens and an 81B warm-up filter on Fuji Provia.

Understanding Exposures

Modern cameras with automatic exposure systems have
made some aspects of achieving good-quality images
much easier, but no system is infallible and an understanding of how exposure
meters work will help to ensure a higher success rate.

An exposure meter, whether it's a built-in TTL meter or a separate hand meter, works on the principle that the subject it is aimed at is a mid-tone, know as an 18% grey. In practice, of course, the subject is invariably a mixture of tones and colours but the assumption is still that, if mixed together, like so many pots of different-coloured paints, the resulting blend would still be the same 18% grey tone.

With most subjects the reading taken from the whole of the image will produce a satisfactory exposure. But if there are aspects of a subject which are abnormal – when it contains large areas of very light or dark tones, for example – the reading needs to be modified.

An exposure reading from a snow drift for instance, would, if uncorrected, record it as grey on film. In the same way a reading taken from a very dark subject would result in it being overexposed and appearing too light on the film.

Technical Details
▼ 35mm SLR camera with a 35-70mm zoom lens, 81C warm-up and polarising filters on Fuji Velvia.

These five exposures were bracketed giving one and two-thirds of a stop less than the meter indicated and one and two-thirds of a stop more. The transparencies which have had less exposure show more highlight detail, less shadow detail and greater colour saturation and those that have had more exposure have less highlight detail, more shadow detail and less colour saturation.

The River Ouysse near Rocamadour in the Lot region of France

I gave two-thirds of a stop more exposure than the meter indicated for this
photograph as the very bright highlights on the water suggested less exposure
than was needed and would have resulted in the image being too dark.

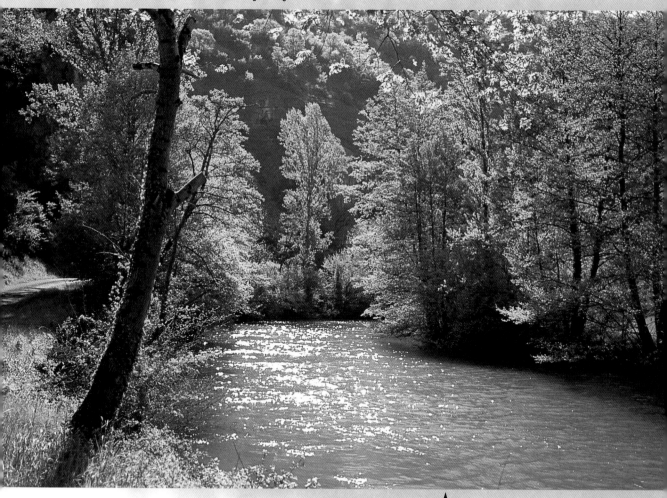

Technical Details ▲
35mm SLR camera with a 35–70mm zoom lens 81C warm-up and polarising filters on Fuji Velvia.

Understanding Exposures

The most common situations in which the exposure taken from a normal, average reading needs to be increased are when shooting into the light, when there are large areas of white or very light tones in the scene, such as a snow scene for example, and when there is a large area of bright sky in the frame.

The exposure needs to be decreased when the subject is essentially dark in tone or when there are large areas of shadow close to the camera. With abnormal subjects it is often possible to take a close-up or spot reading from an area which is of normal, average tone.

Technique

With negative films there is a latitude one stop or more each way and small variations in exposure errors will not be important but with transparency film even a slight variation will make a significant difference to the image quality and, where possible, it's best to bracket exposures giving, a third or half a stop more and less than that indicated, even with normal subjects.

Technical Details

6 x 4.5cm SLR camera with a 55–110mm zoom lens on Fuji Velvia. ▼

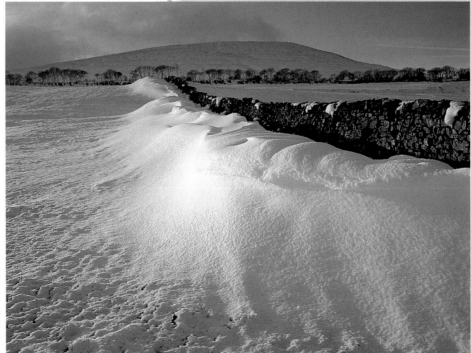

Ribblesdale in Yorkshire, UK

For this sunlit snow scene I needed to give one stop more than the exposure meter indicated to avoid this image recording too darkly.

Rule of Thumb

Many cameras allow you to take a spot reading from a
small area of a scene as well as an average reading and
this can be useful for calculating the exposure with
subjects of an abnormal tonal range or of high contrast.
Switching between the average and spot reading modes
is also a good way of checking if you are concerned about
a potential exposure error. If there is a difference of
more than about half a stop when using transparency
film you need to consider the scene more carefully to
decide if a degree of exposure compensation is required.

Technical Details
35mm SLR camera with a 75–300mm zoom lens and 81B warm-up filter on Fuji Velvia.

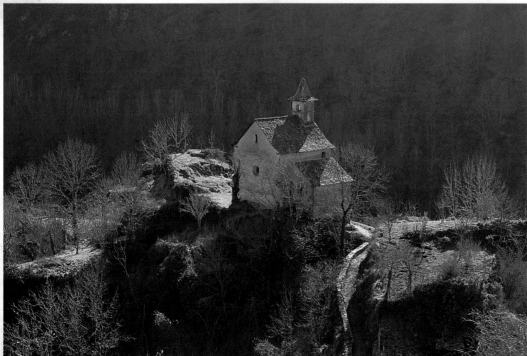

Near Conques in
the Lot region of
France

I gave two-thirds
of a stop less
exposure than the
meter indicated
for this image as
the large area of
darker tone
suggested more
exposure than was
needed, which
would have
resulted in the
lighter details of
the image being
too light.

Choosing Film

There is a huge variety of film types and speeds from which to choose and although, to a degree, it is dependent on personal taste there are some basic considerations to be made. Unless you wish to achieve special effects through the use of film grain it is generally best to choose a slow, fine-grained film for landscape photography if the subject and lighting conditions will permit.

The choice between colour **negative film** and **transparency film** depends partly upon the intended use of the photographs. For book and magazine reproduction transparency film is universally preferred and transparencies are also demanded by most photo libraries. For personal use, and when colour prints are the main requirement, colour negative film can be a better choice since it has greater exposure latitude and is capable of producing high-quality prints at a lower cost.

Although colour film is very widely used in landscape photography there are many qualities in such subjects which can also be used to produce striking **black and white** images. In addition to conventional black-and-white films like Ilford's FP4 and Kodak's Tri X there are also films such as Ilford's XP2 and Kodak's T400 CN which use colour negative technology and can be processed in the same way at one-hour photo labs to produce a monochrome print.

▲ **Technical Details**
6 x 4.5cm SLR camera with a 55–110 mm zoom lens on Ilford's XP2.

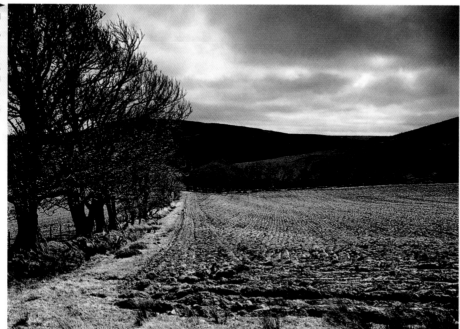

Near Alnwick in Northumbria, UK

The rich tones and textures in this scene made it a good subject for black and white film. The additional control available when making a print in the darkroom enabled me to increase the contrast, print in the sky and hold back detail in some of the darker tones.

Black-and-white infrared film can be very effective for landscape photography when exposed through a red filter. This film is very sensitive and needs to be loaded and unloaded into the camera in very subdued light – a darkroom is best.

For those who like to experiment and produce images with a surreal quality, it can be interesting to use infrared film available in both black and white and colour transparency versions to create images with a most unusual range of tones and colours.

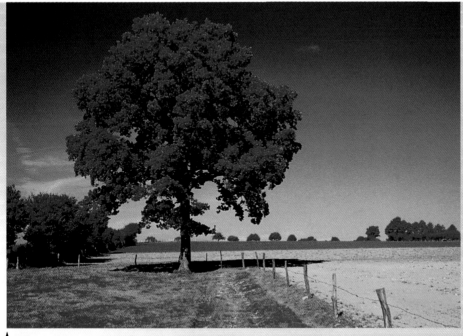

Near Honfleur in the Normandy region of France

This photograph was taken on Kodak's Infrared Ektachrome using the recommended yellow filter, a Wratten 12. The effects of this film are hard to predict and are dependent upon the subject, the filter used and the exposure. It is best to bracket exposures quite widely, based on an ISO rating of 200. I have had very interesting results using tobacco and sepia coloured filters. The film can be cross-processed in C41 chemistry to produce a negative from which even more unusual effects can be obtained.

▲ Technical Details

35mm SLR camera with a 35–70mm zoom lens and a Wratten 12 filter on Kodak's Infrared Ektachrome.

Using Filters

Even in the best conditions, filters are essential,
especially when shooting on colour transparency film, as even the brightest sunny
day with the clearest blue sky and whitest of fluffy clouds can reproduce
disappointingly unless every effort is made to get the very best from a scene.

Technique

A polarising filter is, perhaps, the most useful filter of all as it can influence the colours in a scene selectively and does not alter the overall colour balance of the image. It is equally effective when used with colour print film whereas the qualities created by a warm-up or neutral-graduated filter can be achieved when making colour prints from negatives.

While a polarising filter is mainly used for making blue skies a deeper colour with white clouds standing out in stronger relief they can have a much wider use than this. On overcast days they will often increase the colour saturation of foliage quite dramatically and produce much richer images – the effect on spring or autumn colours can be very striking.

A polarising filter can also help to give greater clarity when shooting distant views and is very useful for subduing excessively bright highlights when shooting into the light, like the sparkle on rippled water. Polarising filters need between one-and-a-half and two stops extra exposure but this will be allowed for automatically when using TTL metering.

Warm-up filters are essential to photographers shooting outdoors on colour transparency film as the colour temperature of daylight can increase far beyond that for which daylight film is balanced, especially on overcast or hazy days and beneath a deep blue sky, when a pronounced blue cast will be created.

Technical Details
35mm SLR camera with a 35–70mm zoom lens,
81C warm-up and polarising filters on Fuji Velvia.

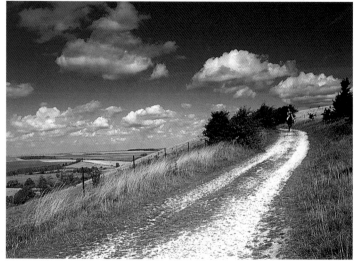

Win Green near
Shaftesbury in
Wiltshire, UK

I used a polarising
filter to help
create the striking
relief of the white
clouds in this scene
and to increase the
colour saturation
of the blue sky.

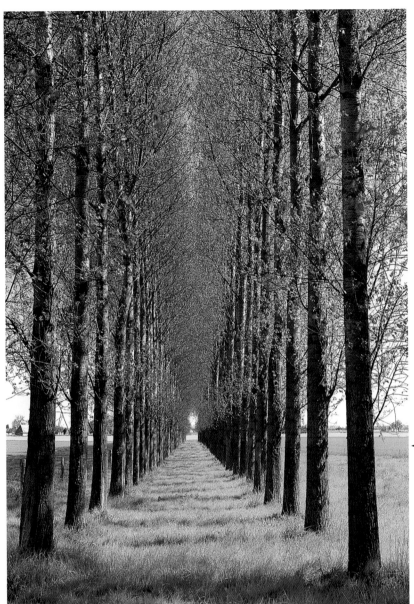

Near Rouen in the Normandy region of France

These two photographs show how the addition of filters affects the colour and quality of the image. The image on the left was taken with 81C warm-up and polarising filters while the one on the right was shot without the benefit of any filters.

◄ Technical Details
35mm SLR camera with a 35–70mm zoom lens, 81C warm-up and polarising filters on Fuji Velvia.

Rule of Thumb

Neutral-graduated filters provide a very effective means of making the sky darker and revealing richer tones and colours. They can also reduce the contrast between a bright sky and a darker foreground, giving improved tones and colours in both. In addition, you can sometimes use a neutral-graduated filter effectively upside down to make a foreground darker.

Card mounts are the most suitable way of storing and presenting colour transparencies. They can be printed with your name and address together with caption information using labels. Added protection can be given by the use of individual clear plastic sleeves which slip over the mount.

Technique

The simplest way of storing mounted transparencies is in viewpacks – large plastic sleeves with individual pockets which can hold up to twenty-four 35mm slides or fifteen 120 transparencies. These can be fitted with bars for suspension in a filing cabinet drawer and quickly and easily lifted out for viewing. For slide projection, however, it is far safer to use plastic mounts, preferably with glass covers, to avoid the risk of popping and jamming inside the projector. When colour transparencies are to be used as part of a portfolio, a more stylish and polished presentation can be created by using large black cut-out mounts which hold up to 20 or more slides in individual black mounts, depending upon format. These can be slipped into a protective plastic sleeve with a frosted back for easy viewing.

Rule of Thumb

For portfolio and exhibition prints, and those where archival permanency is required, it's best to hold the print in place on the mounting board with acid-free tape across the corners and then complete the presentation by placing a bevel-cut mount on top to frame it. You can cut these yourself to size using a craft knife, or there are special tools available, but they can also be bought ready-made in the most popular sizes from art stores.

A colour-balanced light box and a powerful magnifying glass are essential items for the careful editing of colour transparencies.

Prints, black and white or colour, are most effectively presented either individually, or perhaps with two or three compatible images mounted on a page in a portfolio. This can be in book form or as individual mounts in a case or box. For added protection it is possible to have prints laminated.

A portfolio ring-binder album with detachable acetate leaves is an ideal way of presenting prints.

Technique

Even the finest print will be improved by good **presentation** and mounting it flat on to a heavy-weight card is the first stage. **Dry mounting** ensures a perfectly flat, mounted print. This involves placing a sheet of adhesive tissue between the print and its mount and applying heat and pressure, ideally with a dry-mounting press although a domestic iron can also be used.

Rule of Thumb

When selecting work for any form of presentation it is necessary to be highly critical of your pictures. Transparencies need to be carefully edited, spot on for exposure and pin sharp. Use a light box and a powerful magnifier to eliminate any which are sub-standard.

Technique

Building up a body of work is one of the most stimulating and challenging projects for a photographer and the formation of a portfolio or collection of images with a central theme is an excellent way of doing this.

Technique

There are a number of ways of selling your work and finding a potential outlet for it in print. Good landscape photographs are in constant demand by publishers of magazines and books dealing with travel and outdoor pursuits, of which there are a large number, and there is a ready market for most subjects if the photographs are well executed.

Technique

Spend some time researching the market in your local library, or at a friendly newsagents, and see just how the photographs are used in such publications and what type of image they seem to prefer. Make a note of some names, like the editor, features editor and picture editor.

There are some useful reference books available like The Freelance Writers' and Artists' Handbook and The Freelance Photographers' Market Handbook, but these are, at best, only a general guide to potential users and it is vital to study each publication before you consider making a submission.

Books and magazines represent only a small proportion of the publications which use landscape photographs. Other potential outlets include travel brochures, calendars, greetings cards, packaging and advertising.

A good photo library can reach infinitely more potential picture buyers than is possible for an individual and can also make sales to the advertising industry where the biggest reproduction fees are earned.

As a general rule, you will be expected to submit several hundred transparencies initially, and will probably be obliged to allow those selected to be retained for a minimum period of three years. Your selection should be ruthlessly edited as only top-quality images will be considered and you should make sure that no very similar photographs are sent, only the very best of each situation.

Although a good photo library can produce a substantial income in time from a good collection of photographs it will take as much as a year before you can expect any returns and most libraries prefer photographers who make contributions on a fairly regular basis.

Rule of Thumb

If you have a collection of photographs on a particular theme or region and can write, say, 1000 words to accompany them you will have an excellent chance of placing them with the right type of publication.

Exhibitions are a rewarding way of finding a wider audience for your work and a regular check in the photographic magazines will provide you with a list of potential venues. Postal portfolios are another way of showing your work and exchanging ideas. However, perhaps one of the most satisfying ways of displaying your talents is to join an organisation like the Royal Photographic Society and to submit your portfolio to a judging panel with a view to gaining a distinction.

See how the impact of a print can be significantly affected by the way it is mounted and presented.

Glossary

Aperture priority
An auto-exposure setting in which the user selects the aperture and the camera's exposure system sets the appropriate shutter speed.

APO lens
A highly-corrected lens which is designed to give optimum definition at wide apertures and is most often available in the better quality long-focus lenses.

Ariel perspective
The tendency of distant objects to appear bluer and lighter than close details, enhancing the impression of depth and distance in an image.

Auto-bracketing
A facility available on many cameras which allows three or more exposures to be taken automatically in quick succession, giving both more and less than the calculated exposure. This is usually adjustable in increments of one-third, half or one stop settings and is especially useful when shooting colour transparency film.

Bellows unit
An adjustable device which allows the lens to be extended from the camera body to focus at very close distances.

Cable release
A flexible device which attaches to the camera's shutter-release mechanism and which allows the shutter to be fired without touching the camera.

Colour cast
A variation in a colour photograph from the true colour of a subject which is caused by the light source having a different colour temperature to that for which the film is balanced.

Colour temperature
A means of expressing the specific colour quality of a light source in degrees Kelvin (K). Daylight colour film is balanced to give accurate colours at around 5,600 degrees K but daylight can vary from only 3,500 degrees K close to sundown to over 20,000 degrees K in open shade when there is a blue sky.

Cross processing
The technique of processing colour transparency film in colour negative chemistry, and vice versa, to obtain unusual effects.

Data back
A camera attachment which allows information like the time and date to be printed on the film alongside or within the images.

Dedicated flash
A flash gun which connects to the camera's metering system and controls the power of the flash to produce a correct exposure. It will also work when the flash is bounced or diffused.

Depth of field
The distance in front and behind the point at which a lens is focused which will be rendered acceptably sharp. It increases when the aperture is made smaller and extends about two-thirds behind the point of focus and one-third in front. The depth of field becomes smaller when the lens is focused at close distances. A scale indicating depth of field for each aperture is marked on most lens mounts and it can also be judged visually on SLR cameras which have a depth-of-field preview button.

DX coding
A system whereby a 35mm camera reads the film speed from a bar code printed on the cassette and sets it automatically.

Evaluative metering
An exposure meter setting in which brightness levels are measured from various segments of the image and the results used to compute an average. It's designed to reduce the risk of under or overexposing subjects with an abnormal tonal range.

Exposure compensation
A setting which can be used to give less or more exposure when using the camera's auto-exposure system for subjects which have an abnormal tonal range. It is usually adjustable in one-third of a stop increments.

Exposure latitude
The ability of a film to produce an acceptable image when an incorrect exposure is given. Negative films have a significantly greater exposure latitude than transparency films.

Extension tubes
Tubes of varying lengths which can be fitted between the camera body and lens to allow it to focus at close distances. These are usually available in sets of three different widths.

Fill-in flash
A camera setting for use with dedicated flash guns which controls the light output from a flash unit and allows it to be balanced with the subject's ambient lighting when it is too contrasty or there are deep shadows.

Filter factor
The amount by which the exposure must be increased to allow for the use of a filter. A x2 filter requires an increase of one stop and a x4 filter requires a two stop exposure increase.

Grey card
A piece of card which is tinted to reflect 18 per cent of the light falling upon it. It is the standard tone to which exposure meters are calibrated and can be used for substitute exposure readings when the subject is very light or dark in tone.

Hyperfocal distance
The closest distance at which details will be rendered sharp when the lens is focused on infinity. By focusing on the hyperfocal distance you can make maximum use of the depth of field at a given aperture.

Incident light reading
A method involving the use of a hand meter to measure the light falling upon a subject instead of that which is reflected from it.

ISO rating
The standard by which film speeds are measured. Most films fall within the range of ISO 25 to ISO 3200. A film with double the ISO rating needs one stop less exposure and a film with half the ISO rating needs one stop more exposure. The rating is subdivided into one-third of a stop settings i.e. 50, 64, 80, 100 and so on.

Macro lens
A lens which is designed to focus at close distances to give up to a life-size image of a subject.

Matrix metering
See evaluative metering.

Mirror lock
A device which allows the mirror of an SLR camera to be flipped up before the exposure is made to reduce vibration and avoid loss of sharpness when shooting close-ups or using a long-focus lens.

Polarising filter
A neutral grey filter which can reduce the brightness of reflections on non-metallic surfaces such as water, foliage and blue sky.

Programmed exposure
An auto-exposure setting in which the camera's metering system sets both aperture and shutter speed according to the subject matter and lighting conditions. It usually offers choices like landscape, close-up, portrait, action etc.

Pulling
A means of lowering the stated speed of a film by reducing the development times.

Pushing
A means of increasing the stated speed of a film by increasing the development times.

Reciprocity failure
The effect when very long exposures are given. Some films become effectively slower when exposures of more than one second are given and doubling the length of the exposure does not have as much effect as opening up the aperture by one stop.

Shutter priority
A setting on auto-exposure cameras which allows the photographer to set the shutter speed while the camera's metering system selects the appropriate aperture.

Spot metering
A means of measuring the exposure from a small and precise area of the image which is often an option on SLR cameras. It is useful when calculating the exposure from high-contrast subjects or those with an abnormal tonal range.

Substitute reading
An exposure reading taken from an object of average tone which is illuminated in the same way as the subject. This is a useful way of calculating the exposure for a subject which is much lighter or darker than average.